IMAGES
of America

CHICAGO MOTOR
COACH COMPANY

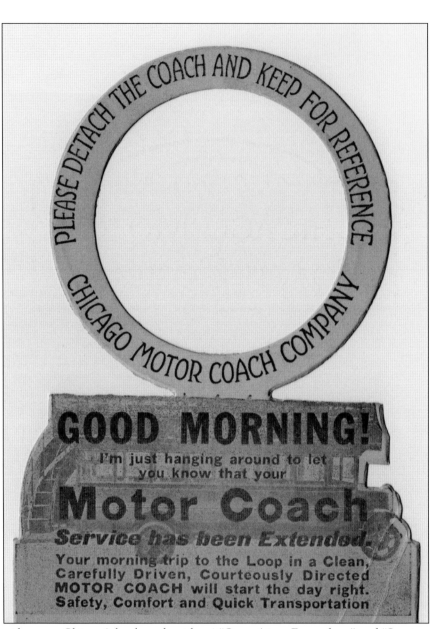

Come ride across Chicago's boulevards with us! "Open Air to Everywhere" and "Service with a Smile" were the slogans adopted by the Chicago Motor Coach. These distinctive cards that were hung on doorknobs announced new motor coach routes forthcoming to the neighborhoods. On the back of the card was a complete schedule. This door hanger advertised the details of extended service for Route 7 Michigan and Midway Plaisance. (John F. Doyle Collection.)

ON THE COVER: Bus No. 500 is shown here in Lincoln Park near the zoo for a publicity photograph. In April 1922, John D. Hertz opened a new plant at Austin and Dickens Avenues on Chicago's West Side. Yellow Coach Manufacturing Company would later become General Motors Truck and Coach Division. The bus is a prototype of the first buses Yellow Coach produced at the new plant for the Chicago Motor Coach Company. (Yellow Coach photograph, Chicago Transit Authority Collection.)

IMAGES
of America

CHICAGO MOTOR COACH COMPANY

John F. Doyle

ARCADIA
PUBLISHING

Published by Arcadia Publishing
Charleston, South Carolina

Printed in the United States of America

Library of Congress Control Number: 2018954523

For all general information, please contact Arcadia Publishing:
Telephone 843-853-2070
Fax 843-853-0044
E-mail sales@arcadiapublishing.com
For customer service and orders:
Toll-Free 1-888-313-2665

Visit us on the Internet at www.arcadiapublishing.com

This book is dedicated to my father, Gerald E. Doyle; my mother, Winifred; my brothers, Gerald and Thomas; my grandfather Frank Minahan; my uncle John Doyle; and aunts Gertrude and Mildred Doyle.

CONTENTS

ACKNOWLEDGMENTS

Special thanks to my wife, Diane J. Doyle, for her editorial assistance, technical writing skills, and, most of all, her encouragement to write this book.

I would like to thank the following individuals and organizations for photographs, proofreading, and historical information:

Michael A. Cardilli, former chairman of the Chicago Transit Authority (CTA) in 1985, and Jack Sowchin, CTA Public Affairs, for allowing the author to borrow a book of 1946 Chicago Motor Coach prints in order to make negatives. I would also like to thank the CTA for allowing me to access their photographic negative files and print pictures of them used in this book.

Albert E. Meier with the Motor Bus Society of Upper St. Clair, New Jersey, for his input and useful research and his *Motor Coach Age* magazines, March 1972 and July–August 1971 editions.

Bruce G. Moffat of the CTA for providing me with copies of the articles from CTA *Transit News and Bus Transportation* magazine, 1952 edition, and a 1948 Chicago Motor Coach map drawn by the CTA. Bruce also reviewed all photographs in this book.

Barney Neuberger for sharing his vintage bus photographs. I purchased his 10¢ snapshots in 1963, not realizing the treasure they would be someday.

George E. Kanary for sharing his knowledge of the city of Chicago—locations, dates, and historic places. He also reviewed my final manuscript.

Acknowledgements are extended to my friend Robert W. Gibson for his tireless effort with the author making negatives from Chicago Motor Coach photographs provided to us from the CTA.

Special thanks to Lawrence Godson for digitally enhancing the CTA maps from 1948 into four separate maps for each motor coach division and the downtown district.

I would like to thank all the photographers cited in the courtesy lines, for without them, there would be no book. Unfortunately, some names do not appear because many of the photographs were taken for company files; those would include Chicago Motor Coach Company (CMC), Chicago Transit Authority (CTA), and Chicago Motor Bus Company (CMB). Unless otherwise noted, all images are from the John F. Doyle Collection, acquired over a 50-year period.

We would like to extend our appreciation to Jeff Ruetsche from Arcadia Publishing for his assistance and support in making this book a reality.

INTRODUCTION

In the 1920s, Chicago was the cradle of the bus-building industry in the United States. Streetcars following the Paris example were not allowed to operate over Chicago's 203 miles of boulevards and park district streets.

This unique system paved the way for motor-bus operations. The first major bus line in Chicago was on Sheridan Road in 1917; it was taken over by John D. Hertz in 1922 and became the Chicago Motor Coach Company. Hertz would manufacture Yellow Coach buses in Chicago until 1927. At that time, General Motors Corporation (GMC), who had controlling stock, would move the manufacturing of buses to Pontiac, Michigan, and become the largest bus builder in the world.

I was born in 1938; a year later, my parents moved from the South Side of Chicago to the North Side due to apartment shortages. We lived in a big redbrick apartment building at 4605 North Dover Street. My earliest memories were the buses that ran on Wilson Avenue. I think the first words that I was able to read were those printed on the sides of those yellow and green buses: Chicago Motor Coach Company. Because of the war, my father had no car, so all the visits to cemeteries and relatives were on the streetcars, which I liked. In fact, today I am a streetcar fan, but then the only thing I wanted to be was a bus driver.

A very early memory for me was pushing my Radio Flyer wagon down Wilson Avenue. I stopped to watch a Chicago Motor Coach westbound bus discharge a passenger at Beacon Street. The motor coach always discharged passengers on the far side of an intersection, crossing that street first, and then stopping to pick up or discharge riders. The stops were zones with a motor coach bus stop sign standing on a pole. As I watched the bus pull away from the curb, I was fascinated by the sound of the diesel engine, a sound that made you feel as though you were really going somewhere. At age four, I decided the only thing I wanted to be when I grew up was a Chicago Motor Coach bus driver. From then on, my Radio Flyer wagon became a motor coach bus. I had my daily runs down Wilson Avenue around Broadway, north to the end of Goldblatt's Department Store and turning to Racine, back on Wilson Avenue, and ending the run in my building's courtyard-like backyard. After each round trip, my reward was a candy cigarette.

I was now getting sophisticated with my great uncle's streetcar puncher and made up transfers. Soon, I outgrew my Radio Flyer wagon and, at the age of nine, got a bike; by ten, I was a *Herald American* paperboy. Then I would go to the motor coach barn and search for unused packets of transfers from the trash. I now did my runs on my Schwinn bike. To mimic running through Lincoln Park like the motor coach, I would circle through the nearby cemeteries. Soon, I was riding the motor coach every day, also taking my younger brother Tommy, who was handicapped, with me. I would make a round trip down in the morning and, after delivering my newspapers, another trip in the afternoon.

Now, I was really becoming sophisticated, and in my bedroom, I set up a steering wheel on my desk and with a dollar's worth of pennies for my changer, away I went. There was no more riding around on bikes for me playing bus driver. My bedroom now became a Chicago Motor Coach Transit Diesel! I had my runs every day, swing shift and all.

Saturday also was a big day for me, since Ravenswood bus barn was four blocks away. Inside the garage, the buses were packed "like sardines." And yes, I was now playing the real thing right after paper delivery. My buddy John Monahan would usually come with, and away we would go, pretending to be driving. We were able to open and close the air doors and work the air brakes. When out of air, we would just move on to the next bus. Time stands still when you are young, but between the bus barn and my bedroom setup, I must have worked for the Chicago Motor Coach for 30 years.

The mechanics did not like us, but I never knew why until years later, when I drove RTA buses part-time. The reason was that on Monday, the mechanics would have to start moving the buses outside very early in the morning. And, as I said, they were packed like sardines. Because there was no air left in the buses we played in, those buses could not be moved, and the mechanics had to waste time running the air up five minutes per bus.

By the time I was 13 years old, playing bus driver was out, but inside of me, the motor coach was with me every day. Eleven years after the first time I sat in my Radio Flyer, the motor coach would be gone forever. It was purchased and absorbed into the Chicago Transit Authority (CTA) in 1952 and, with it, my dreams of driving for the Motor Coach.

The nearly forgotten story of the motor coach will live again in this book, and we can "Go the Motor Coach Way" one more time."

On March 25, 1917, the first double-deck buses of the Chicago Motor Bus Company began bus operations from their new garage at 6307 North Broadway on Chicago's far North Side. Behind the garage was an attached two-story building at 1124 Rosemont Avenue that became the headquarters and offices along with an employee restaurant of the new company.

The new bus route would start at Devon Avenue and Clark Street 1600 west at 6400 north and run east into Sheridan Road, south on Sheridan Road, and through Lincoln Park, crossing the river on the Rush Street Bridge. At that time, it was known as the busiest bridge in the world; Michigan Bridge had not yet opened. Working its way back to Michigan Avenue to Jackson Boulevard, the route went west to State Street, north on State Street, east on Washington Street, north on Michigan Avenue, and returning the same route.

About half the runs via Clarendon Avenue would turn west on Wilson Avenue ("Clarendon Wilson Route"), 4600 North, and terminate their runs at Clark Street. Some runs on Sheridan Road would also terminate at the Edgewater Beach Hotel at 5300 North Sheridan Road. This Spanish Colonial Revival, state-of-the-art hotel provided a perfect ride into the Chicago Loop for hotel guests. In good weather, it was almost like a sightseeing service. Due to increased ridership, a new North Division garage was opened at 4711 North Ravenswood Avenue in 1925.

In 1916, a former horse streetcar barn at Racine and Belden Avenues on Chicago's Near North Side was used to assemble the first 51-passenger double-deck open-top bus bodies provided from the St. Louis Car Company, a streetcar manufacturer. The bus bodies would slide into a motor tractor that was equipped with a 50-horsepower Moline Knight Sleeve Valve Engine. The front-wheel-drive tractors almost doomed the company, since the engineering was rather poor and the cost was high.

In 1917, Chicago Motor Bus had applied for the South Side Park District franchises. In 1918, a new company Chicago Stage also applied. Fifth Avenue Coach Company of New York was the interest behind Chicago Stage. Applying again in 1920, the Public Utilities Commission decided that the tractor buses were too expensive to operate at 11¢ a mile compared to 4¢ on the New York buses.

On January 20, 1920, the South Side routes were awarded to Chicago Stage. On March 18, 1920, because of financial difficulties, Chicago Motor Bus went into receivership. The bus manufacturing of Chicago Motor Bus was spun off as a separate entity, named the American Motor Bus Company with plans to build the New York Type K double-deck buses for Chicago and other North American cities at the Belden Avenue plant.

American Motor Bus Company and Chicago Motor Bus Company now became subsidiaries of Lake Shore Motor Bus Company. Lake Shore then sold enough bonds to emerge Chicago Motor Bus from receivership in 1921.

In February 1921, a third contender applied for the South Side certification: the Depot Motor Bus Lines. This company had a route from the railway depots to the Carson Pirie Scott (also known as Carson's) department store at State and Madison Streets. This route was operated by Carson's and had originally been a horse-drawn omnibus operation.

The success of Chicago Motor Bus after coming out of receivership attracted the attention of John Daniel Hertz, a car salesman in Chicago. Schandor Herz was born into a Jewish family in

Sklabina, Slovakia on April 10, 1879. His family immigrated to Chicago when he was five years old. In 1915, John D. Hertz (his name was Americanized) went into partnership with Walden W. Shaw, who had started a livery service. The company was named Yellow Cab.

In 1920, a new plant was built at Austin and Dickens Avenues on Chicago's West Side. Shaw divested himself to pursue other interests, and Hertz changed the name to Yellow Cab Manufacturing Company on April 1, 1920. By 1923, taxi cab sales quadrupled throughout North America.

With help from other Chicagoans, including William Wrigley Jr., Albert Lasher, Hertz, and his partner Charles A. McCullock, in September 1922, they purchased Lake Shore Motor Bus Company, the operators of Chicago Motor Bus Company.

Importing management from New York, John A. Ritchie became president and the Chicago Motor Coach Company was born on September 30, 1922. Fifth Avenue Coach also owned Chicago Stage, and without ever operating a bus, the South Side franchise reverted to the Chicago Motor Coach.

With the North and South Side franchises now secured, it was time to secure the West Side boulevards. Depot motor bus lines that lost the bid for the South Side routes were taken over by the Omnibus Corporation of New York, the parent company of Fifth Avenue Coach Company and the Chicago Motor Coach Company. For legal purposes, Depot Motor Bus ran as a lease until dissolved in 1932. When Depot Motor Bus, now Chicago Motor Coach, extended its downtown route to the near Northeast area of Streeterville via Ohio and Walton Streets, the route number would be 57 Ohio Street Depots.

With a new bus garage at 4532 West Adams Street at Wilcox Avenue, the West Side operations began on March 16, 1924. The heavy trunk lines were Route 26 Jackson Boulevard and Route 31 Washington Boulevard with direct service to the Loop from Austin Boulevard, which was the dividing line between Chicago and Oak Park. Route 26 Jackson Boulevard was extended to the Adler Planetarium on May 12, 1930.

In 1923, the Public Utilities Commission ordered Chicago Motor Coach to inaugurate South Side service within six months. The first 14 buses were put into service on Route 1 Drexel and Hyde Park Boulevards on April 15, 1923. By October of that year, all the new routes were in service. A new South Side garage at 52nd Street and Cottage Grove Avenue opened in the spring of 1923. Within a year, Chicago Motor Coach had grown to 22 million riders.

Chicago Motor Coach would come into conflict with the Chicago Surface Lines in regard to the Northwest Side of Chicago, where the motor coach operated for 18 months. On March 6, 1930, the Chicago Motor Coach Company ceased operations under an Illinois Supreme Court decision, and the bus routes were taken over by the Chicago Surface Lines and replaced with trolley bus and bus operations. The motor coach would not attempt any new routes for 16 years and reached an annual peak in ridership of 69 million in 1929.

By April 1923, a new plant was built next to the Yellow Cab plant at Dickens and Austin Avenues for the Yellow Coach Manufacturing Company. All bus building would be transferred from the old American Bus Building facility on Belden Avenue to the new plant. Chicago would now become the nation's main bus builder.

The quiet Moline Knight Sleeve Valve engine built in their Moline, Illinois, factory was acquired by Hertz in April 1923 and renamed Yellow Sleeve Engine Works. By 1936, those engines would become obsolete as General Motors perfected engines situated in the rear motor compartment for new equipment.

In 1925, Yellow Cab Manufacturing was sold to General Motors, and Yellow Cab Operations were sold to Checker Cab of Chicago. By 1925, General Motors had controlling stock in Yellow Coach and, in 1927, moved the bus building operations to Pontiac, Michigan. The company would now become Yellow Truck and Coach Manufacturing Company. In 1943, General Motors purchased the remainder of Yellow Coach stock, and the name would be changed to General Motors Truck and Coach Division. General Motors would become the largest bus builder in the world. John D. Hertz, who was on the board of General Motors, indeed had come a long way from the village of Sklabina, Slovakia.

In 1933, a boiler factory built in 1923 was purchased and converted to a bus garage. It was located at 4221 Diversey at Keeler Street. The garage would house Route 52 Addison and Route 34 Diversey. The CTA would use the garage until 1973.

Benjamin Weintraub, formerly of Fifth Avenue Coach Company, would succeed Ritchie and become president of the Chicago Motor Coach Company until it was sold to the CTA in 1952. Weintraub was responsible for extending ridership to 81 million passengers a year. An excellent manager, he brought the transit bus to the peak of its development under his direction.

The last new bus routes put on by the Chicago Motor Coach (except for Route 58 Wacker-Northwestern Station on May 12, 1947) were Route 56 Wilson/LaSalle and Route 4 Jeffery in 1946. Route 56 would follow Route 53 and after exiting Lincoln Park at LaSalle Drive West would follow LaSalle Drive South into the Financial District; this route only operated on weekdays. Route 4 Jeffery would follow Route 1 Drexel and Hyde Park and exit Jackson Park, south on Jeffrey Boulevard, and short turn at 100th Street and Bensley Avenue, while other runs would go further southeast to 112th Street and Green Bay Avenue, near the Indiana State line. Also, the same year, two 5¢ shuttle routes were opened from the Grant Park parking lots to the downtown business area: Route 48 Monroe parking lot and Route 49 Soldier Field parking lot.

In a few years, what would prove to be a significant event for the Chicago Motor Coach Company was the creation of the Chicago Transit Authority (CTA), a public operating agency. On September 30, 1947, the CTA purchased the Chicago Rapid Transit Company (the "L") along with four bankrupt streetcar companies operated by the Chicago Surface Lines. This would leave the Chicago Motor Coach as the last privately owned city transit company in operation. It must be noted that at all times the motor coach was profitable.

The fare on the motor coach since day one of Chicago Motor Bus days in 1917 was one thin dime, full fare, and a nickel for 12 years or younger. Thirty-one years later, on September 18, 1948, the city allowed the motor coach to raise the fare to 13¢. In 1951, the motor coach would again be authorized to raise the fare to 15¢. After the sale of the motor coach to the CTA, the fare would be raised to 20¢.

On September 30, 1952, the Chicago Motor Coach Company was sold to the Chicago Transit Authority for $16,641,541.62. Ironically, this occurred 30 years to the day that the company came into existence.

The CTA would operate the motor coach for a few years as the Boulevard Division because of different employee unions. In a short period of time, three of the five garages would be closed, and motor coach employees would be dropped to the bottom of the CTA's seniority list. For many, this would be a windfall, as the CTA paid well and had excellent benefits. Some of the drivers even broke in on streetcars, and with seniority building up, some ended up working their way back to their old motor coach routes.

For the most part, the motor coach lines still operate today with minor changes. For example, Chicago Motor Coach route 51 Sheridan Road, the first major bus route in Chicago, operates today as CTA Route 151 and is one of the busiest bus routes in Chicago.

The Hertz colors from the beginning were yellow and black; today, they are the same. Interestingly, they were the colors of the Austro-Hungarian Empire into which Schandor Herz was born. One can only wonder if that is the reason he chose those colors.

A good part of the money from the sale of the Chicago Motor Coach was reinvested in Hertz Rent-A-Car, a fitting end for John D. Hertz's *Boulevard Route*. John D. Hertz passed away on October 8, 1961; indeed, he was an incredible man who must have led an incredible life.

One

OPEN AIR
TO EVERYWHERE

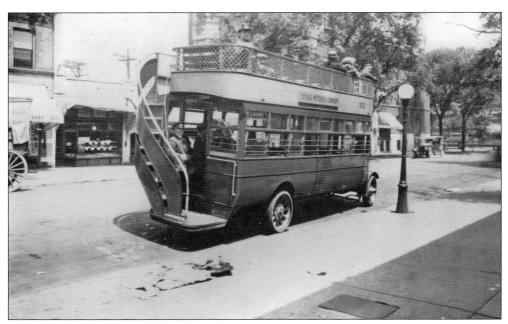

North Side double-deck bus operations on Sheridan Road began on March 25, 1917, with open-top buses, a driver, and a conductor. By March 30, 1923, the Chicago Motor Coach Company would operate Chicago Motor Bus and secure the franchises to operate over the South and West Side Park District streets. Bus No. 301 is shown here at Clark Street and Wilson Avenue about to depart eastbound for the Chicago Loop. The author was raised in the far background building pictured. (Barney Neuberger Collection.)

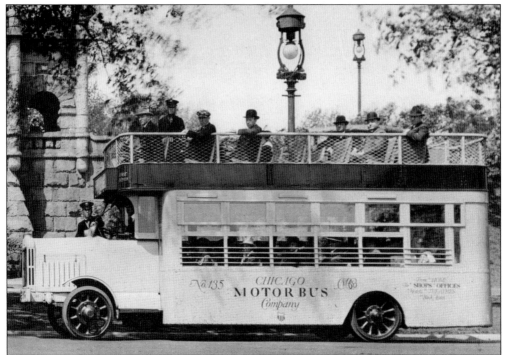

Chicago Motor Bus Company No. 135 is posed for the camera at the Ulysses S. Grant Monument off North Lake Shore Drive in 1917. This Lincoln Park monument was dedicated in 1881 with 200,000 people attending. Although new, the bus would prove that it was never engineered properly. The bus body was supplied by the St. Louis Car Company, a streetcar builder, and a tractor was built that slips into the bus body. (Railway Negative Exchange.)

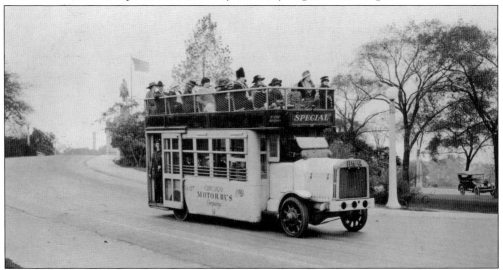

A front-wheel-drive tank-type tractor trailer, Chicago Motor Bus Company No. 127, is shown here in Lincoln Park for a publicity photograph in 1917. Looking north to the Ulysses S. Grant Monument, this section of roadway went around the Grant Monument from both the south and north ends, where it would join back again with Lake Shore Drive (today's North Ridge Drive). Note the distinct park lamppost. (G.A. Green–R.A. Crist Collection.)

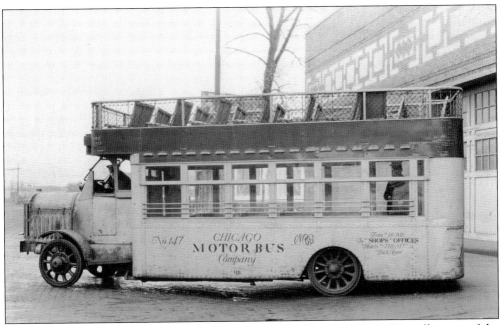

In the early morning of May 19, 1919, Chicago Motor Bus Company No. 147 is pulling out of the new Rosemont bus garage at 6307 North Broadway, a short distance from Devon Avenue. This state-of-the-art garage would become a Chicago Motor Coach garage and, for a while, a Chicago Transit Authority (CTA) garage. In the 1960s, it became a Jewel Food Store, and today it is a mosque. (E.E. Schart photograph.)

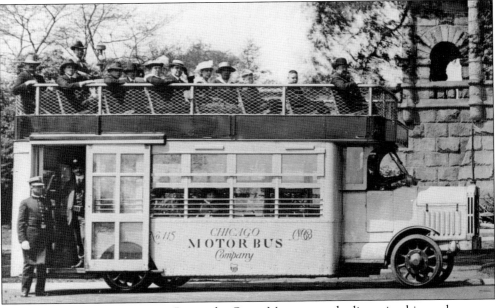

In this view of a Chicago Motor Bus at the Grant Monument, the livery is white and maroon. The policeman is a Chicago patrolman. With 135 parks, 203 miles of boulevards, and 28 miles of lakefront, on May 1, 1934, the park district established their own police department with a distinctive uniform and badge. With the city needing the men and their equipment, they were absorbed back into the city police on December 31, 1958. (Railway Negative Exchange.)

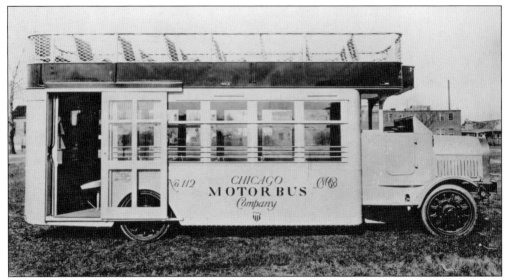

Chicago Motor Bus No. 112 is shown here after it left the assembly factory at Belden and Racine Avenues on Chicago's Near North Side in 1917. There would be 50 of these tractor trailer buses and 13 extra tractors equipped with 50 horsepower Moline-Knight sleeve valve engines. These buses were not practical at 11¢ per operating mile. Eventually, they would be replaced with coaches at 4¢ per mile. (CMB photograph, CTA Collection.)

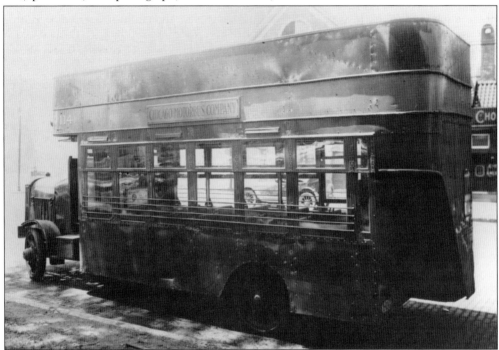

Chicago Motor Bus No. 114 is shown here after a 1922 rebuilding and painted in a new green livery. Applying for a South Side license to connect Washington and Jackson Parks to the Chicago Loop, Chicago Motor Bus lost out to the new Chicago Stage Company owned by Fifth Avenue Coach Company of New York. The reason: 11¢ per mile for Chicago Motor Bus and 4¢ for Chicago Stage. (Railway Negative Exchange, Barney Neuberger Collection.)

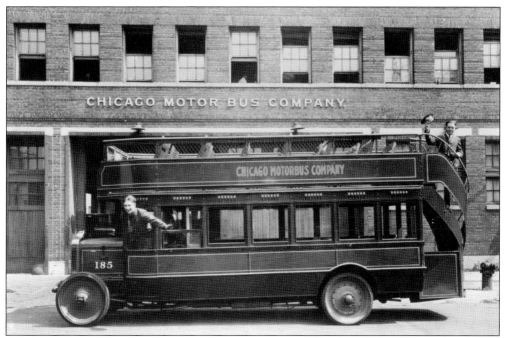

On March 18, 1920, Chicago Motor Bus went into receivership and became a subsidiary of Lake Shore Motor Bus, who sold bonds taking Chicago Motor Bus out of receivership. Lake Shore, a subsidiary of Fifth Avenue Coach Company of New York, in turn, began modernizing Chicago Motor Bus. Here we see the first Type L 51-passenger bus built by Fifth Avenue Coach being photographed in front of the company offices at 1124 Rosemont Avenue in 1922. (G.A. Green–R.A. Crist Collection.)

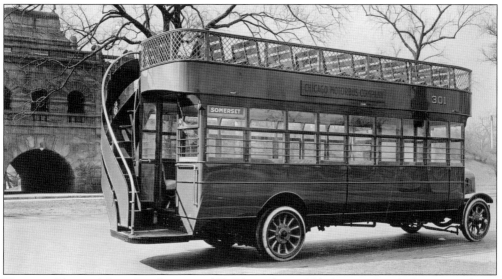

This new Chicago Motor Bus Company (CMB) coach is a Fifth Avenue Coach Company of New York K bus built in Chicago. No. 301 is shown here in 1922 at the Grant Memorial on Lake Shore Drive just south of the Lincoln Park Zoo. Built at the American Bus Company factory (formerly Chicago Motor Bus factory) at Belden and Racine Avenues in what originally was a horse-drawn streetcar barn. (G.A. Green–R.A. Crist Collection.)

15

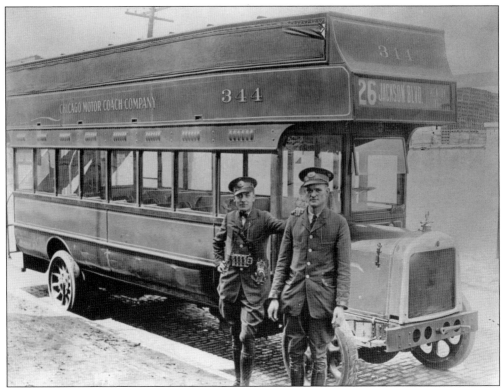

Chicago Motor Coach No. 344 was built by the American Motor Bus Company at the Belden Avenue plant in 1923. This Type K 68-passenger coach is operating on Route 26 Jackson Boulevard between Kenton Avenue and State Street. Herb Graby was the dime-fare collector and with his changer is ready to go into service. (CMC photograph, CTA Collection.)

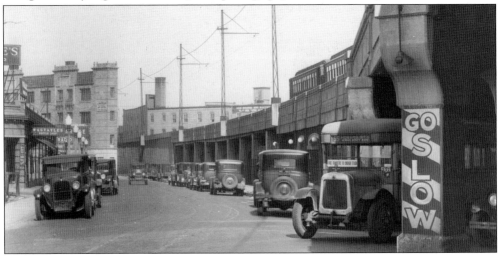

Bus No. 257 a single-deck bus operating on Route 55, a short connector line, is passing the Rogers Park–Loyola rapid transit station in March 1929. This bus will soon terminate its southbound run at the bus loop at Devon and Sheridan Road. Route 55 will operate north on Sheridan Road from Devon, west on Pratt, north on Ashland, and west on Howard and terminate at Ridge Boulevard. (Barney Neuberger Collection.)

16

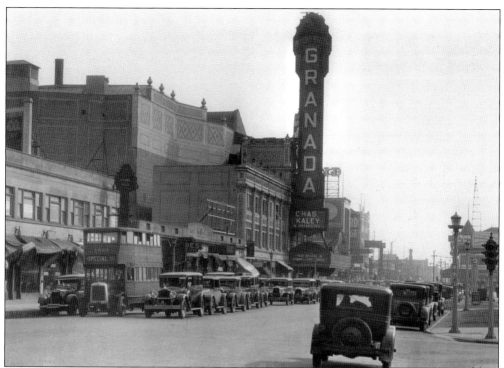

The splendid Granada Theater features Chas Kaley and his live orchestra along with this week's movie, *True Heaven*, with sound. This view looks south down Sheridan Road from Loyola to Devon Avenues. Sheridan Road will turn east, and Broadway will begin; eastbound Devon will end. Bus No. 1529 leads the parade of cars and is signed as a "Special." (Barney Neuberger Collection.)

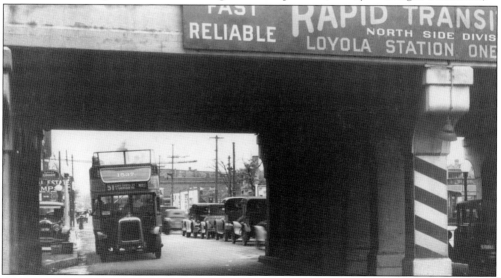

Chicago Motor Coach Company No. 1537 (formerly 537), built by Yellow in 1924, is eastbound on Sheridan Road in March 1929. The bus is going under the "L" tracks. Broadway ends at Devon Avenue and becomes North Sheridan Road; Devon at Broadway ends and becomes East Sheridan Road. Within a few blocks, Sheridan Road will turn south again. No. 1537 is signed for Washington-State, where the driver will start his return trip. (Barney Neuberger Collection.)

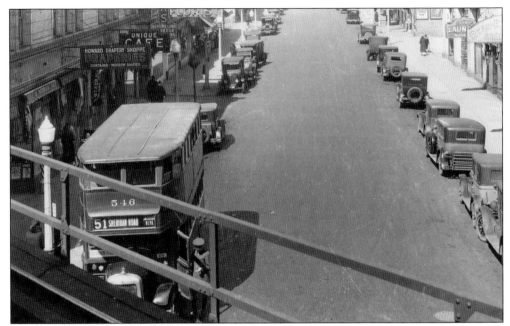

It is March 1929, and the bus driver is checking his timepiece for his departure into the Chicago Loop. Bus No. 546 is a 66-passenger Yellow Z-13 built in 1924 and enclosed in the motor coach rebuilding program of 1927. Shown here from the Howard Street "L" station, this view looks north down Paulina Street. Note the special lampposts that were allocated throughout the city for small business areas. (Barney Neuberger Collection.)

Bus No. 1513, operating on Route 51 Sheridan Road, is crossing the Michigan Avenue Bridge southbound in 1931. The bridge, part of Daniel Burnham and Edward Bennett's *Plan of Chicago*, opened on May 14, 1920. The bridge was modeled after the Pont Alexandre III Bridge built for the 1900 Paris Exposition. Pine Street north of the bridge officially became North Michigan Avenue and, later, was called the Magnificent Mile. (Fred Borchert photograph, Robert W. Gibson Collection.)

18

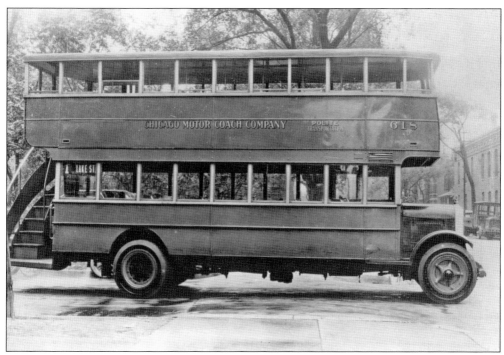

Chicago parks had three distinct districts. To easily identify the buses running in the respective districts, they were painted as follows: West Division was green, North Division was tan, and South Division was red. Here, Coach No. 618 is seen in brilliant red with a black engine hood. This bus was originally in the 300 class; however, they were renumbered 571 through 640 in 1926. In 1928, all the buses would be repainted green. (CMC photograph, CTA Collection.)

Coach No. 525, a Yellow Z-B-200, was built with an open top in 1923, but was semi-enclosed in 1926, as noted on the upper deck of this bus. This picture was taken after its rebuilding. It looks mighty cold to go on top rather than ride in the warm lower deck. A change was coming rapidly, and it must be remembered that 10 years earlier, people were riding in drawn carriages. (CTA Collection.)

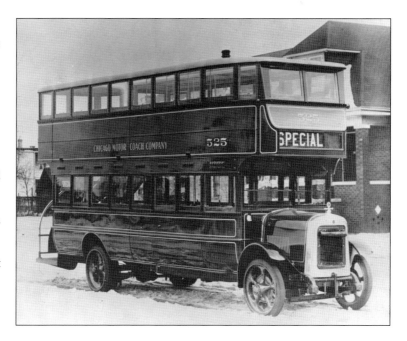

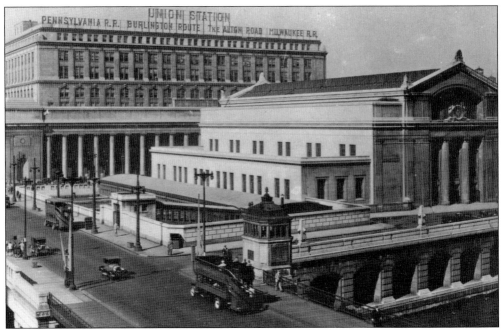

On May 16, 1925, the magnificent Union Station opened. It was served by three Chicago Motor Coach routes with other routes added in 1927 and 1947. Shown here, near the time of the opening, are an open-top Type K that just crossed the South Branch of the Chicago River and a closed-top Type K approaching Canal Street. These buses would serve the West Division routes, 26 Jackson, 36 Douglas, or 27 Independence. (*Chicago Tribune* photograph, Robert W. Gibson Collection.)

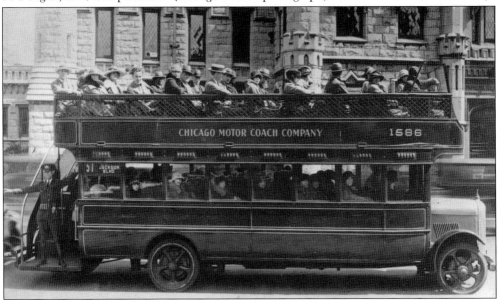

No. 1586, a Yellow Coach Type Z, is being held up for a publicity photograph. The bus appears to be in service with the sign set for Route 51. The pumping station behind the bus is at 821 North Michigan Avenue, across from the famed Chicago Water Tower, a neo-Gothic structure built in 1869. Both structures survived the Great Chicago Fire of 1871. (CMC photograph, CTA Collection.)

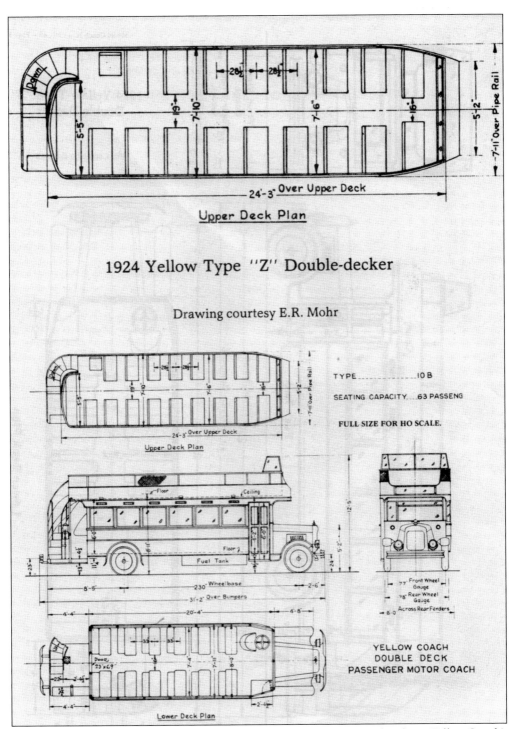

Upper Deck Plan

1924 Yellow Type "Z" Double-decker

Drawing courtesy E.R. Mohr

TYPE..............10 B

SEATING CAPACITY....63 PASSENG

FULL SIZE FOR HO SCALE.

Upper Deck Plan

YELLOW COACH
DOUBLE DECK
PASSENGER MOTOR COACH

Lower Deck Plan

This excellent drawing for *Model Coach News* No. 46, drawn by E.R. Mohr, shows Yellow Coach's famous Model Z double-decker open-top bus. This bus was built for many systems between 1923 and 1925. Chicago Motor Coach had 278 of this type of bus. Later, the company would rebuild many of them into closed-top and one-man operated buses.

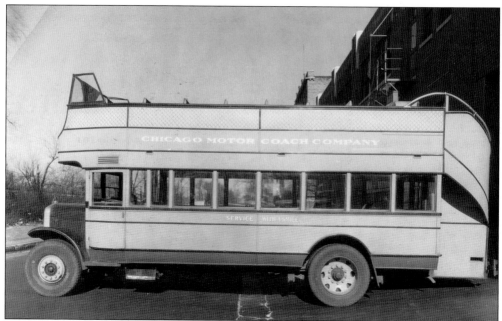

Chicago Motor Coach No. 161, built by the American Motor Bus Company in 1922, is shown here before rebuilding with an open top and painted in the North Division tan livery. This bus will be part of a rebuilding program started after 1927 to fully enclose the upper deck. No. 161 has just exited the front door of the Ravenswood Garage. (CMC photograph, CTA Collection.)

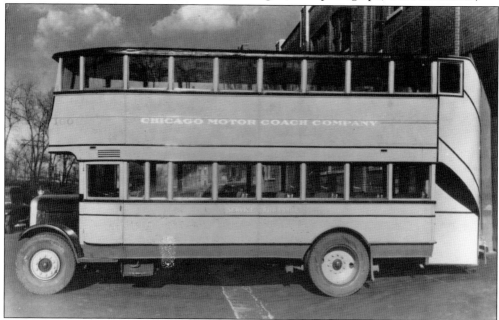

Chicago Motor Coach No. 160 is shown here after the conversion to a fully enclosed bus at the Ravenswood Garage, 4711 North Ravenswood Avenue, in this view looking north. It seems probable that all 24 of the buses in this series were converted. Again, this was an age of experiments that were very worthwhile and would contribute to producing the best transit buses in the world. (CMC photograph, CTA Collection.)

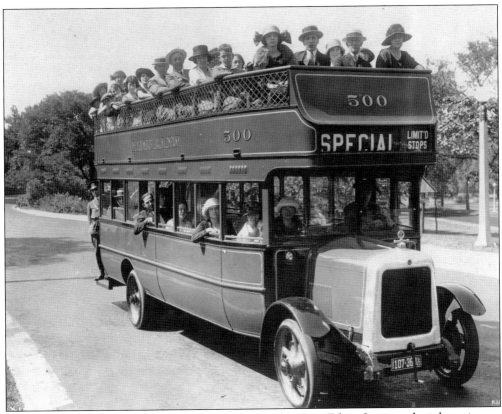

Bus No. 500 was a hand-built prototype designated a Type Z bus. It entered trial service on July 18, 1923. After testing, the bus would be dismantled, and full production would start with a 45-bus order for the Chicago Motor Coach Company. These were the first buses built at the new Yellow Coach plant. The bus is shown here on Stockton Drive in Lincoln Park for a Yellow Coach publicity photograph. (Yellow Coach photograph, CTA Collection.)

Bus No. 568, built by Yellow Coach as a semi-enclosed double-deck bus, was used by the Chicago Motor Coach Company until 1938. The bus is painted in brilliant red for the South Division, with seating capacity for 66 passengers—28 on the lower deck and 36 on the upper deck. This unit and others were rebuilt during 1928 with fully enclosed tops, pneumatic tires, and a front entrance door, which permitted one-man operation. (CMC photograph, CTA Collection.)

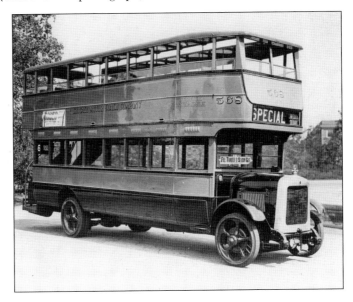

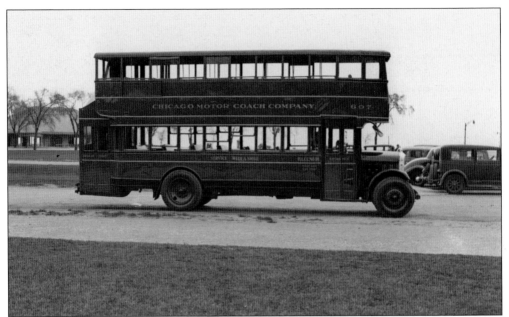

Bus No. 607, built by American Motor Bus Company in 1923, is shown here after being enclosed, including the stairway, and converted to a one-man operation in 1928. The rear door would be an exit door only. Double-deck operations across the nation would eventually be replaced with single-deck bus operations. Only the Chicago Motor Coach Company and Fifth Avenue Coach Company of New York would purchase modern double-deck buses in 1936 and operate them into the 1950s. (CMC photograph, Barney Neuberger Collection.)

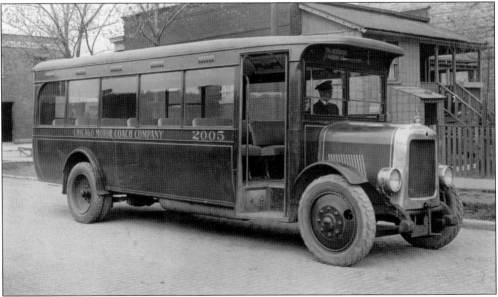

The new bus shown here in 1924 was the first single-deck bus produced by Yellow Coach for the Chicago Motor Coach. These small 29-passenger buses were the perfect answer to shuttle bus operation or light patronage runs. This bus is signed as a West Division shuttle bus on Route 26 Jackson Boulevard. It would operate as an extension of that line to Austin Boulevard and North Avenue. Note the streetcar-style seats. (CMC photograph, Barney Neuberger Collection.)

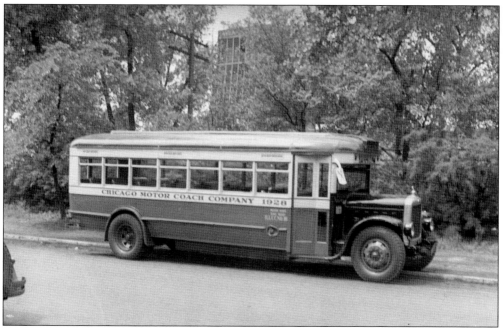

Wilson Avenue had a three-cent "Bathing Beach" bus, using older equipment such as this bus in 1938. The route went south on Clarendon to Montrose east and circled the Lake back to Wilson Avenue terminating at Ravenswood. It was quite a site, with the kids in swimsuits with inner tubes, and moms with lunches and their little ones. A day's work for a driver was 33 round trips. In 1942, newer buses were assigned. (CMC photograph, Barney Neuberger Collection.)

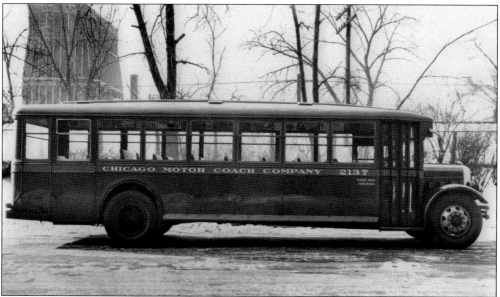

This could be called the "Cadillac" of the single-deck bus; it was part of a 75-bus order built for the Motor Coach by Yellow Coach in 1929. Designated a Type Z AAA-1, it would seat 40 passengers. Splendid in olive green with a lighter-green belt rail, it poses on a winter day in front of the Ravenswood Garage. In the background are the tracks of the Chicago & Northwestern Railway. (CMC photograph, Barney Neuberger Collection.)

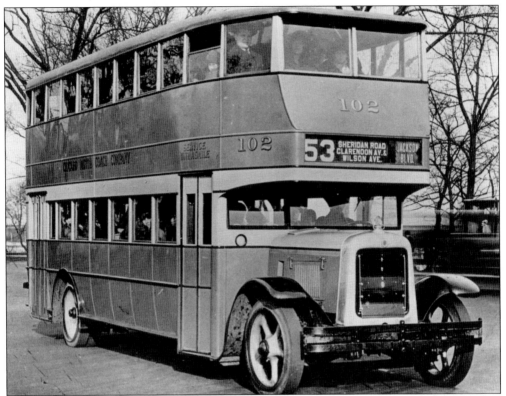

Coach No. 102 is one of the two experimental buses built by Yellow Coach in 1926. This bus had a gas/electric drive system, which proved unsuccessful. By 1939, all new buses would be diesel. World War II would also perfect the diesel engine. The bus is signed for Route 53; it would turn into the Loop at Jackson Boulevard. (CMC photograph, CTA Collection.)

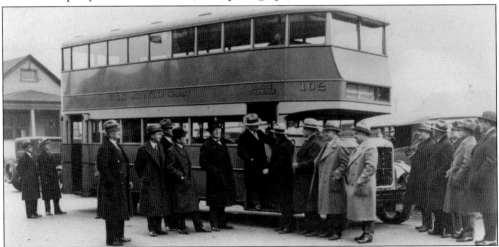

This view of Bus No. 102, one of two demonstrators built by Yellow Coach, is drawing a crowd of dignitaries. The coach, just received, has yet to have destination roll signs installed. Designated Yellow Z-AAC-297, the bus had a short life. John Hertz was an innovator, so experiments such as this bus were worthwhile. In one year, Yellow Manufacturing would be moved to a new General Motors plant at Pontiac, Michigan. (Chicago Public Library.)

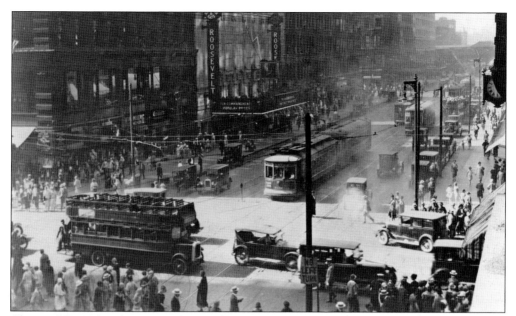

Chicago Motor Coach Bus No. 527, a Yellow Type Z-A 67 passenger bus built in 1923, is shown here crossing State Street eastbound on Washington Boulevard. Servicing Route 31 Washington Boulevard, the route will turn north on Michigan Avenue and terminate at the Michigan Bridge at Wacker Drive; it will return the same way. Route 31 would go west on Washington Boulevard and terminate at Austin Boulevard, Chicago's city limits. (John F. Doyle Collection.)

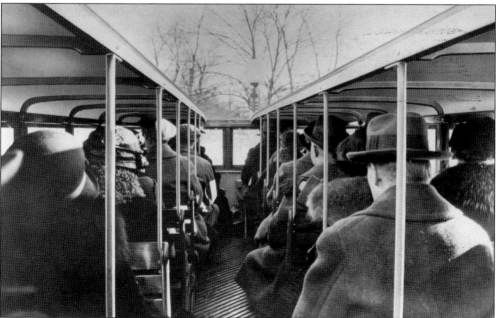

There were many reasons the tops were not enclosed, and one was the viaducts, as the buses were very high. When approaching a low viaduct, the conductor would come up the rear stairs and inform the riders to stay seated. For obvious reasons, the passengers obeyed. In this experiment, the ceiling in the middle of bus 102 is semi-enclosed so riders could somewhat stay out of the elements. (CTA photograph.)

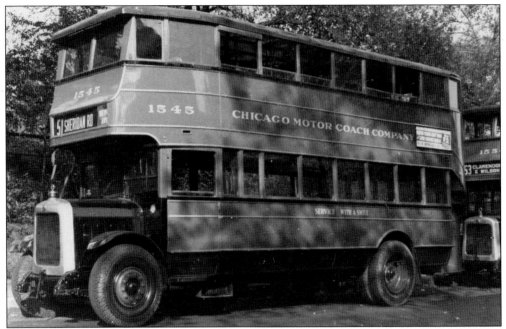

Ninety-two of these handsome buses would be built for the motor coach in 1923 and 1924. Shown here after being enclosed in 1927, they were designated as Yellow Type ZA 67-passenger buses. With the slogan, "Service with a Smile," these buses are painted in the North Side tan livery. Parked on the northwest corner of Ravenswood at Wilson Avenue, the buses are awaiting their running time. (CMC photograph, Barney Neuberger Collection.)

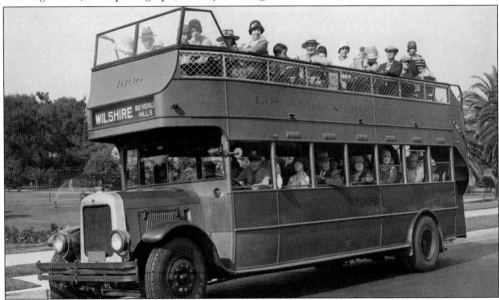

By 1925, Yellow Coach was selling buses throughout North America. In 1925, a joint venture of the Los Angeles Railways and the Pacific Electric Interurban Railway established the Los Angeles Motor Coach Company. Shown here in 1928 is a Los Angeles motor coach company bus in a publicity photograph signed for the Wilshire Boulevard route. (Art's Photograph Service, Los Angeles.)

Two

SEE CHICAGO,
THE CITY BEAUTIFUL

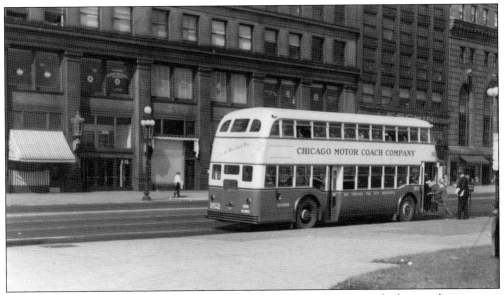

The new era of rear-engine and single- and double-deck buses has arrived, along with automatic transmission, a dime-fare register, air doors, and one-man bus operation. A new South Side 72 passenger northbound bus is seen loading passengers in front of the McCormick Building on Michigan Avenue just north of Van Buren in 1936. Nicknamed "the Queen Mary," Yellow Coach would build 140 of these buses for Chicago between 1936 and 1938. (Fred Borchert photograph, Robert W. Gibson Collection.)

On a summer Sunday morning in 1936, the ever-present lions guarding the Art Institute of Chicago are seen. A new Chicago Motor Coach double-deck bus on Route 51 Sheridan Road is about to turn west onto Adams Street in front of the Peoples Gas Company Building. This 21-story building was designed by D.H. Burnham & Company, opening in 1911. In 1984, the building was added to the National Register of Historic Places. (Fred Borchert photograph, Robert W. Gibson Collection.)

Southbound Yellow Coach Type 720, a 72-passenger double-decker, is shown here at Madison Street, operating on Route 1 Drexel–Hyde Park Boulevard in 1938. In the background is the classical Grant Park colonnade, built in 1917. Demolished in 1953 to make way for underground parking, this peristyle colonnade would return in 2004 with the opening of Millennium Park. This handsome reproduced structure today sits in its 1917 location. (John F. Doyle Collection.)

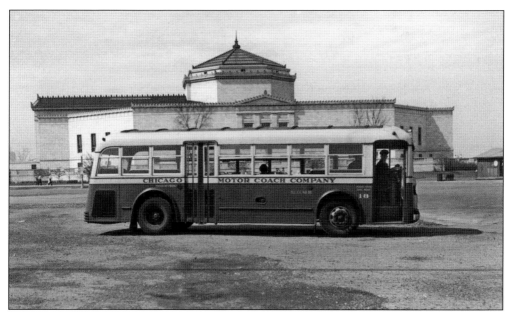

In 1935, Chicago Motor Coach Bus No. 18 poses for the photographer as Chicago's first rear-engine bus, making history and changing the dynamics of the bus building industry forever. This 32-passenger bus is one of the 45 buses built by Yellow Coach at Pontiac, Michigan. In the background is the John G. Shedd Aquarium, opened on May 30, 1930, and served by the Motor Coach's Route 26 Jackson Boulevard. (Fred Borchert photograph, Robert W. Gibson Collection.)

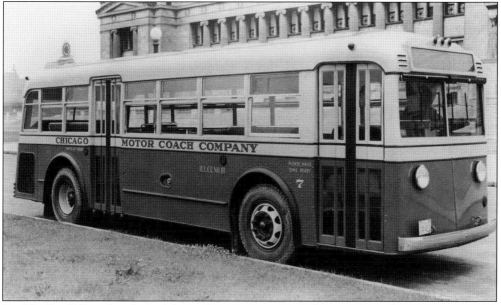

Bus No. 7, a Yellow Coach Model 728, thirty-two-passenger bus, is so new that destination signs are not yet installed. Just delivered in 1935, it is being photographed in front of the Museum of Natural History (the Field Museum). Although not opened until 1921, the museum was an outgrowth of the Columbian Exposition when the Columbian Historical Association was formed. In 1893, Marshall Field donated $1 million for the future museum named after him. (Railway Negative Exchange.)

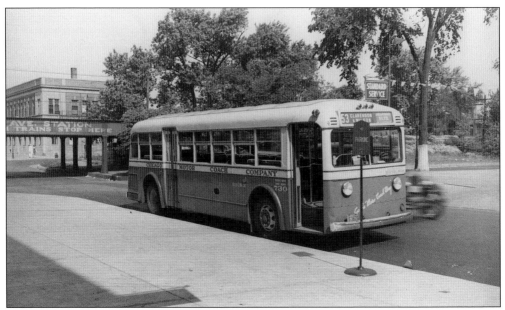

Chicago Motor Coach Bus 730, a 36-passenger gasoline bus built by Yellow Coach Manufacturing Company at Pontiac, Michigan, awaits its running time into the Loop at Ravenswood and Wilson Avenues in this view looking northwest in 1937. In the background is the Northwestern Railway's right-of-way, and to the left, not seen in the picture, is the Wilson Avenue Northwestern train station. This would be the starting point for Route 53. (Fred Borchert photograph.)

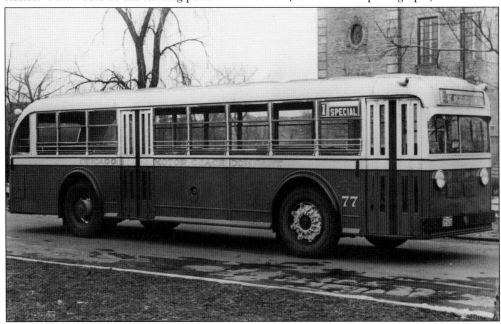

Chicago Motor Coach Bus No. 77 is a New York City Omnibus Corporation 40-passenger gas bus built by Yellow Coach in 1934; it is on trial loan to Chicago. Shown here in Washington Park on January 30, 1935, the motor coach never ordered this model. The New York City Omnibus Corporation was the owner of Chicago Motor Coach, Fifth Avenue Coach Company, and Madison Avenue Coach Company of New York. (CMC photograph, Barney Neuberger Collection.)

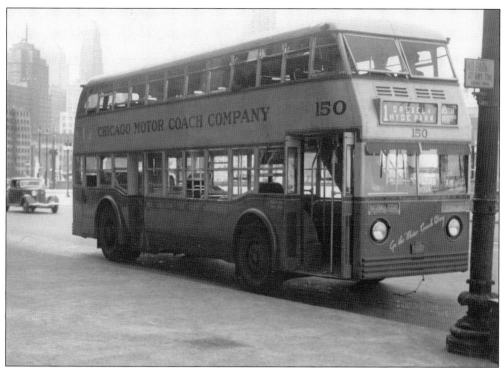

Bus No. 150 awaits its running time in 1937 at the Michigan Bridge on Wacker Drive in the view looking northwest. Route 1 went south on Michigan Avenue to 24th Street, east to South Park to Oakwood Boulevard, east on Oakwood to Drexel Boulevard, south to Hyde Park Boulevard, then east and south on Hyde Park to South Shore Drive. Route 1 would terminate on Chicago's Southeast Side at 83rd Place and Brandon Avenue. (CMC photograph, CTA Collection.)

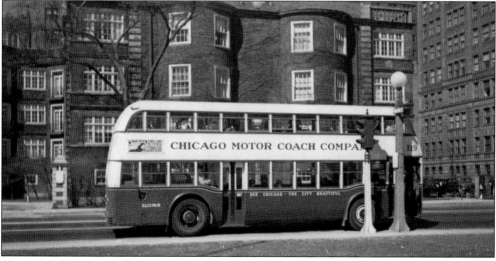

Shown here is a new Yellow Coach 72-passenger bus. Viaducts had always been a problem for the double deckers, so those buses had to make sure they did not stray into unknown territory. The new "Queen Mary" was actually lower than the older buses. A South Side driver "dead heading" back to the garage decided to take a shortcut with a low viaduct, and it is very clear what happened. (Fred Borchert photograph, Robert W. Gibson Collection.)

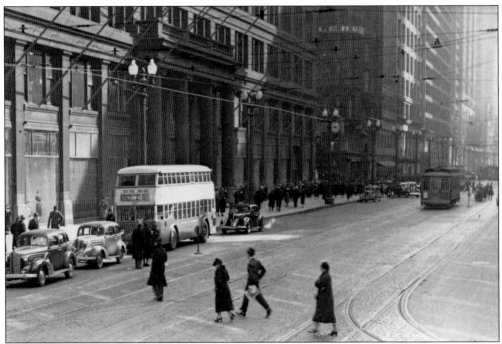

A Route 51 double-decker bus signed for Sheridan Road is stopped to pick up passengers in front of Marshall Field & Company's flagship store on State Street in 1938. Opened in 1892, it was once the second-largest department store in the world, covering one square block between Randolph Street and Washington Street and State Street and Wabash. Avenue. Marshall Field is noted for his famous quote, "Give the lady what she wants." (George E. Kanary Collection.)

Christmas is near. Looking north down State Street, this view shows a crowded street with Chicago Surface Lines streetcars and heavy vehicular traffic on a wet November 5, 1940. Two northbound buses have just turned into State Street from Adams Street to begin their trips north. In the background is a single-deck front-engine bus. This would be the last year these type of buses would operate into the Loop. (CTA Collection.)

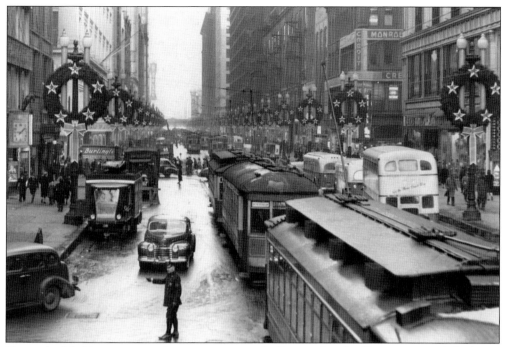

How colorful this scene was: the streetcars were brilliant red and yellow cream, and the livery on northbound buses were grass green and light-yellow cream. With whistle in hand, a Chicago policeman has two very busy streets to attend to: State and Madison Streets. The dividing line between Chicago's North and South Sides was Madison Street. Note the winter storm windows on the Chicago Surface Lines streetcars. (CTA Collection.)

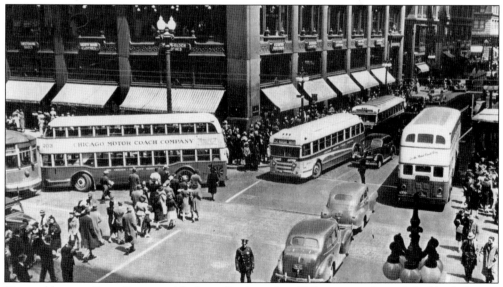

Pictured here at State Street and Jackson Boulevard in 1941 is an eastbound double-decker on Route 26 Jackson headed to the planetarium. On the northeast corner, bus No. 203 is followed on to State Street by a Route 52 Addison to Austin bus and a Route 53 Clarendon-Wilson to Ravenswood bus. The policeman directing traffic is a Chicago Park District policeman. This separate city force had 203 miles of boulevards to patrol. (David Eisendrath photograph.)

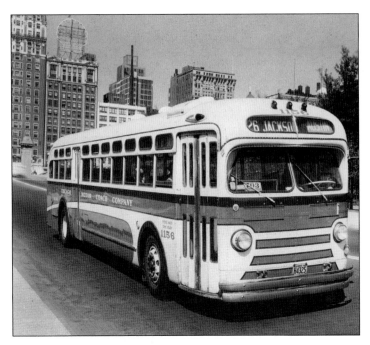

Bus No. 1156 is eastbound to the planetarium on Balbo Drive on a Sunday morning in 1941. The driver has already changed the outbound destination to Austin Boulevard in anticipation of the return trip. This bus delivered from Yellow Coach (GM) in 1940 was the most modern bus in the world. Thousands of this type of bus would be produced, a marvel of American ingenuity. This basic design would last until 1959. (Yellow Coach photograph, CTA Collection.)

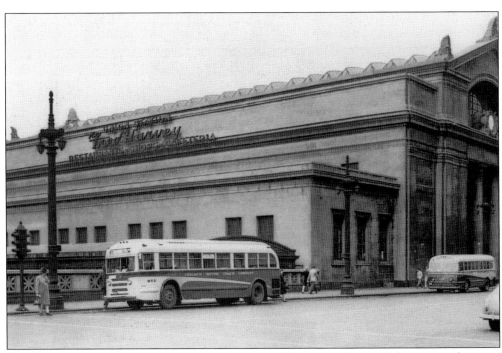

Seen looking southeast from Canal Street is a Route 57 bus and a Route 42 downtown shoppers' Ford transit bus. On the side of Union Station is the marquee of Fred Harvey, that wonderful chain of Southwest railroad restaurants/cafeterias, served by waitresses known as "Fred Harvey girls." Specials included broiled fish almondine, potatoes O'Brien, and Hawaiian slaw for 75¢. Apple pie was an additional 15¢. (*Chicago Tribune* photograph, Robert W. Gibson Collection.)

In this scene is a CMC bus heading south across the Michigan Bridge, a double-deck trunnion bascule bridge, and in the foreground the stairway leading down to the lower level of Michigan Avenue. That level was the original grade. In the background, from left to right, are famous buildings: the 333 North Michigan building and the Carbide and Carbon Building, the London Guarantee and Accident Building, the Lincoln Mather Tower, and the side of the Wrigley Building. (CMC photograph, CTA Collection.)

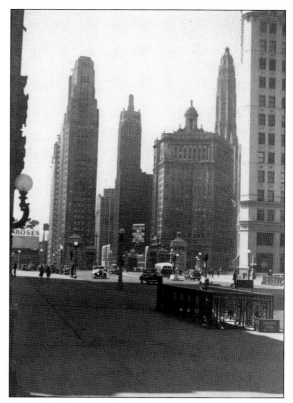

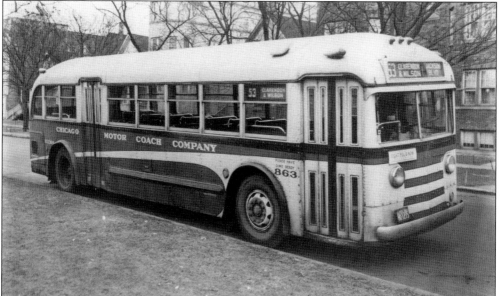

Chicago Motor Coach No. 863 is photographed near the Ravenswood Garage in 1943. The sign on the bus, "Fight Polio Now," reminded the public of this serious threat to children in 1943. "Send Your Dimes to the White House" was the program that led to the vaccine that would end this crippling summer virus. Dr. Jonas Salk developed the vaccine, licensed in 1955. (Barney Neuberger Collection.)

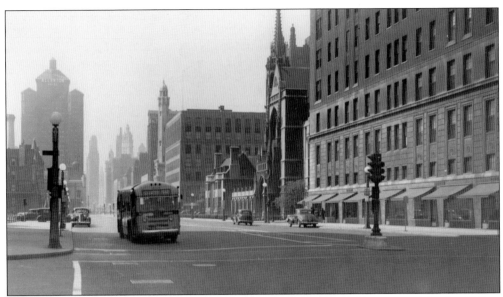

The Magnificent Mile will never be seen this quiet again. Bus No. 867 was one of the first Yellow Coach diesel buses for the motor coach and is shown here at Delaware Street in 1942. In the background is the famous Allerton Hotel, and to the right is the Fourth Presbyterian Church of Chicago at 126 Chestnut Street. It was added to the National Register of Historic Places in September 1975. (CMC photograph, CTA Collection.)

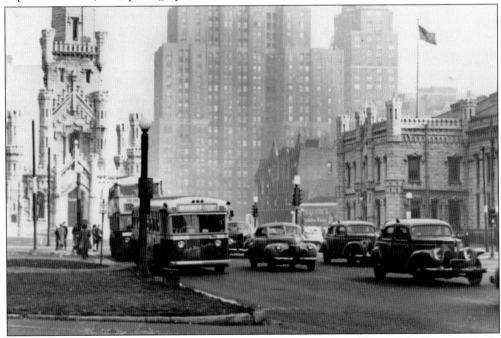

Shown here are the Chicago Water Tower and pumping station that survived the Fire of 1871. As the song goes, late at night while Chicagoans were all in bed, Mrs. O'Leary lit a lantern in the shed. Her cow kicked it over, then winked her eye, and said, "There'll be a hot time in the old town tonight." Although started near Catherine O'Leary's house, the cow was not the culprit. (CMC photograph, CTA Collection.)

Bus No. 132, an Outer Drive Limited, is turning south into Sheridan Road from East Sheridan Road in 1946. In the background is the impressive Mundelein College for Women, which was the first skyscraper college for women in the world opening in 1930. It was a perfect ride downtown for the students. Today, the building is the Mundelein Center for the Fine and Performing Arts, which is affiliated with Loyola University. (CMC photograph, CTA Collection.)

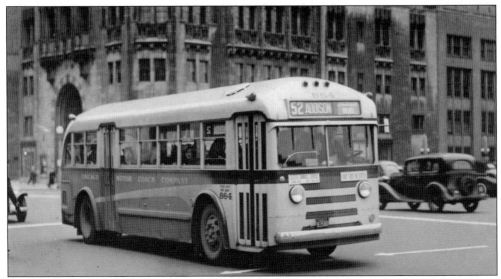

Bus No. 864 is crossing Hubbard Street in 1943 and is about to cross the Michigan Bridge. Built in 1939 as a Yellow Coach 720 model, this group of 50 buses would be the first diesel buses operated by the motor coach. By the end of the war, the motor coach would be an all diesel operation, except for some double-deckers and Ford Transits. In the background is the Tribune Tower. (CMC photograph, CTA Collection.)

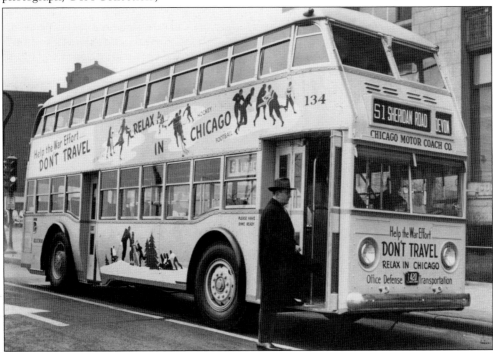

This double-deck bus is posed for a publicity photograph at Broadway and Devon Avenue in 1944. To help the war effort, this livery heralded a theme to stay in Chicago, rather than travel and consume gasoline. The advertising was paid for by the Office of Defense Transportation (ODT). All new transit vehicles had to be approved by ODT and would be delivered in the ODT livery of gray and white. (CMC photograph, CTA Collection.)

Chicago Motor Coach No. 861 is southbound on Hamlin Avenue in 1946. After making a stop at the Garfield Park Conservatory, it is being photographed from the platform of the Lake Street "L." Serving Route 36 Douglas Boulevard, the route will take Hamlin into Independence Boulevard, east on Douglas Boulevard into Roosevelt Road to Ashland Boulevard, and then north on Ashland Boulevard to Washington Boulevard east and terminate at State and Jackson Boulevard. (CMC photograph, CTA Collection.)

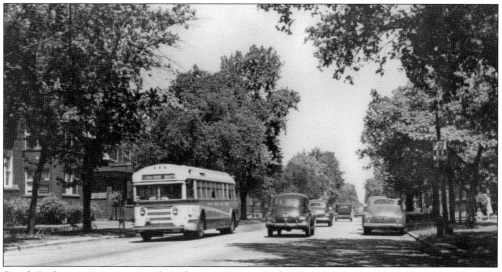

South Parkway turns into South Park Avenue near 60th Street. It was originally Grand Boulevard, and today it is Martin Luther King Jr. Drive. Operating on South Park Avenue in 1946 is an 800 Series bus near 73rd Street, outbound to 81st Street. A very heavy route and feeder into the Jackson Park "L" at 63rd Street, the route also had a short line operating between 65th Street and 33rd Street. (CMC photograph, CTA Collection.)

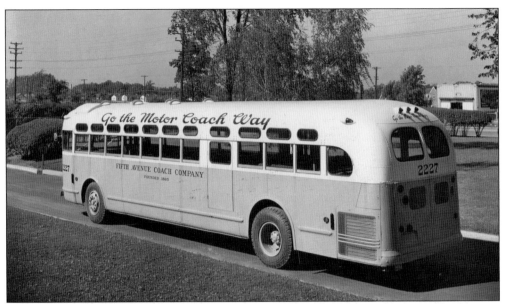

During World War II, the Office of the Department of Defense Transportation (ODT) was responsible for allocating transit vehicles, including streetcars, to companies that needed new equipment. Those vehicles would be built somewhat austere to save on needy wartime materials. Pictured is a Fifth Avenue Coach Company bus in the ODT livery of battleship gray and white. (General Motors photograph.)

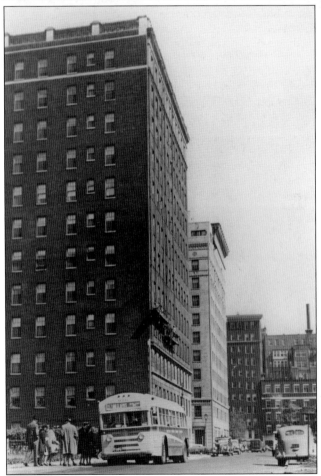

Bus No. 876 is on Route 57 in 1946 at DeWitt Place and Delaware Place in Streeterville. Route 57 began life as Depot Motor Bus lines owned and operated by the Carson, Pirie, Scott department store serving the downtown railway depots. After motor coach ownership in 1932, the line was extended to the near northeast area of Streeterville, terminating at Walton Street and DeWitt Place. (CMC photograph, CTA Collection.)

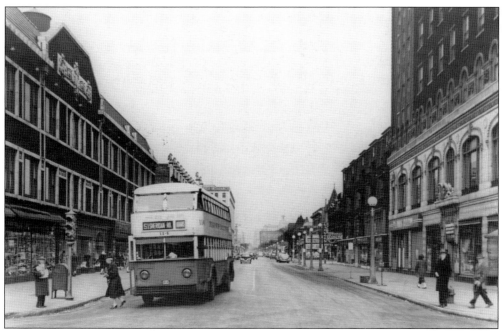

Chicago Motor Coach Bus No. 114 is shown here on Sheridan Road at Wilson Avenue looking north in the Uptown area of Chicago in 1946. The bus in this picture is gasoline powered and was in the first group of 100 buses delivered in 1936; it was designated Yellow Coach 720. None in this group were converted to diesel. In 1938, another 40 buses were delivered and converted to diesel operation in 1941. (CMC photograph, CTA Collection.)

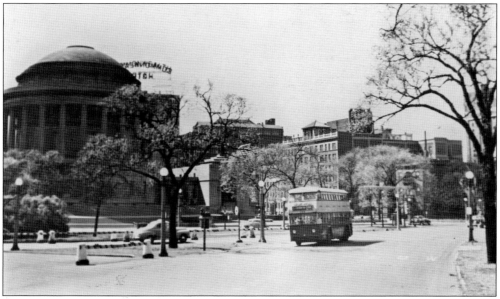

A Route 51 bus signed for its south destination into the Loop has just exited Sheridan Road at Diversey Parkway and is entering Cannon Drive in Lincoln Park in 1946. In the background is the magnificently domed Beaux Arts Elks National Memorial building on Lakeview Avenue. Built as a memorial to those who died in the war, it was completed in 1926. The architect for this Chicago treasure was Egerton Swartwout. (CMC photograph, CTA Collection.)

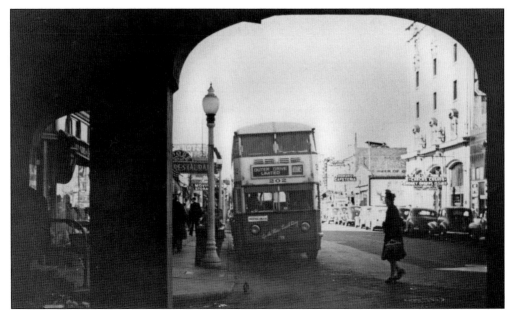

Yellow Coach No. 202, an Outer Drive Limited, is awaiting its departure at 7600 North Paulina Street at Howard Street near the Chicago city limits of Evanston. No. 202 will run local on Sheridan Road to Foster Avenue 5200 North, then enter the Outer Drive (Lake Shore Drive) as a non-stop express to Walnut Street, 900 North and follow Michigan Avenue to Adams Street. The return trip will start northbound at Adams and State Streets. (CMC photograph, CTA Collection.)

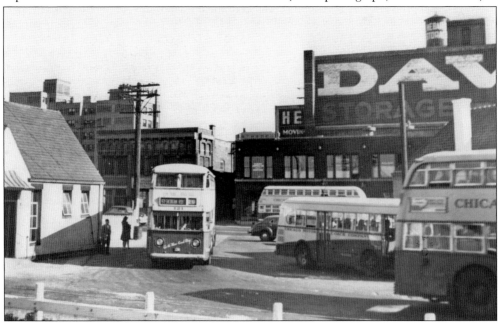

A motor coach terminal was located on the northeast corner of Broadway and Devon Avenue. The purpose was to short turn Route 51 Sheridan Road buses that did not need to run to Howard Street and was the terminal point for the Route 55 short line "Howard-Ashland." The Ford transit single-deck was an ODT-allocated gas bus. The Motor Coach had enough paint to repaint those buses. (CMC photograph, CTA Collection.)

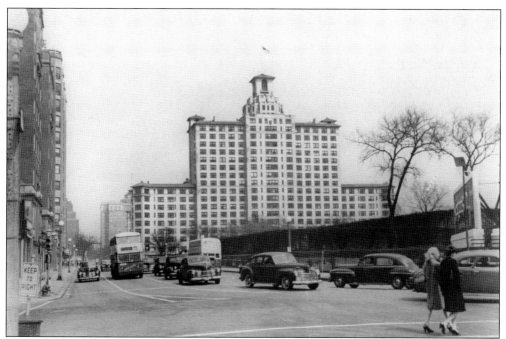

Bus No. 132 is about to turn off Sheridan Road at Foster Avenue and will swing onto Lake Shore Drive, running express to Michigan Avenue and Walnut Street. The Edgewater Beach Hotel, a Spanish Colonial Revival, opened in 1916 and was famous for its summer boardwalk restaurant on Lake Michigan. Designed by Benjamin H. Marshall and owned by the brothers Toban and James Connary, it closed in 1967 and was demolished in 1970. (CMC photograph, CTA Collection.)

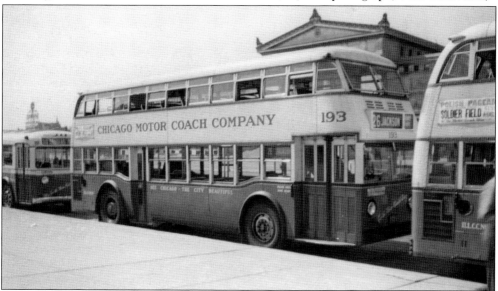

The motor coach was exclusive to all major attractions throughout the Park District system. The buses shown here, although not signed as "Charter," are probably extras awaiting the end of an event to transport riders on their respective bus routes. The event may be the Polish Pageant at Soldier Field on Sunday, August 8, 1946. The buses are across the street from the Field Museum on Fourteenth Drive, later McFetridge Drive. (CMC photograph, CTA Collection.)

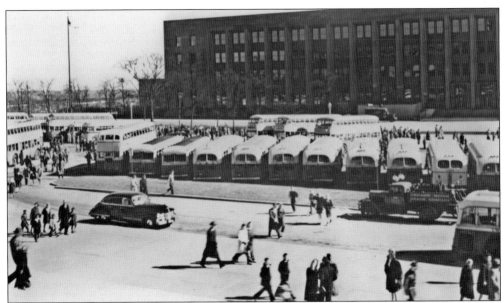

As evidenced by this photograph, if the parks held an event, the motor coach could handle it. Looking southeast, this view shows the Chicago Park District Administration building, 425 East McFetridge Drive. The building was erected after the Public Consolidation Act of 1934, which combined the park districts into one. The building, with its strong Works Projects Administration (WPA) influence, would be demolished in 2001. Soldier Field was behind the building. (CMC photograph, CTA Collection.)

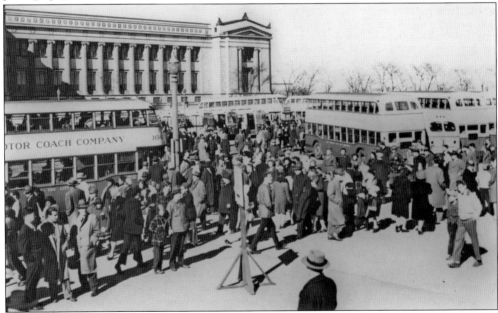

April 6, 1946, saw the special event of Army Day at Soldier Field. Pres. Harry Truman was the main speaker. Dwight D. Eisenhower, the future president, also spoke. The gala event was well attended, with a flyover, military reenactments, and military displays. A fine day it must have been, taking place eight months after World War II ended. In the background is the Field Museum. (CMC photograph, CTA Collection.)

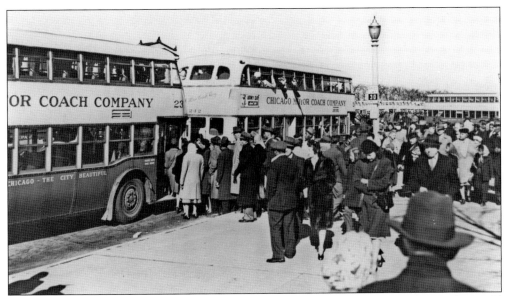

Going home on the motor coach after Army Day at Soldier Field on what appears to be a cold April 6, 1946. The special buses dropped off passengers throughout staging areas. Some of the buses would be "running extra" on regular runs. Yellow Nos. 231 and 242 were part of the second order of 40 double deckers in 1938; they were converted to diesel in 1941. (CMC photograph, CTA Collection.)

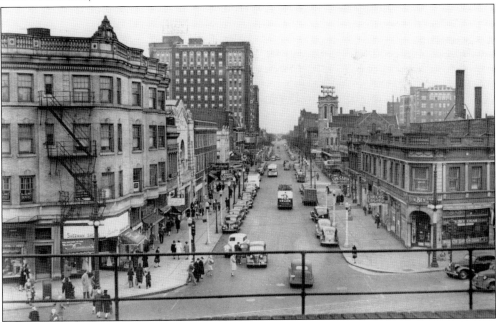

This view looks east from the "L" platform at Wilson Avenue and Broadway in 1946. This point would be the original terminal for the North Side "L" opening on May 21, 1900. The line by 1912 would reach Wilmette. Evanston Avenue was changed to Broadway because the area was to become a theater district, which included the Aragon Ballroom and the magnificent Uptown Theater. However, the area eventually became a shopping district. (CMC photograph, CTA Collection.)

The motor coach would eventually be in conflict with the Chicago Surface Lines regarding the Northwest Side of Chicago, where they operated for 18 months. The Illinois Supreme Court awarded those routes to the surface lines. Several of those lines would now be converted to trolley bus operation. A J.G. Brill trolley coach, built in 1937, pictured near Harlem Avenue, is about to turn east into Diversey Avenue to Western Avenue. (Robert W. Gibson photograph.)

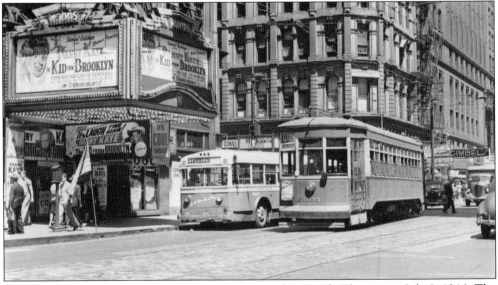

The Kid from Brooklyn in Technicolor is playing at the Woods Theater on July 9, 1946. The scene is at Randolph and Dearborn Streets in this view looking northeast. The Chicago Surface Lines streetcar is operating on the Elston Avenue line. The 700 series of Chicago Motor Coach buses would soon be gone. These would be the last gas buses, along with the ODT Ford transits operated by the Chicago Motor Coach, except for some gas double-deckers, retired in 1950. (T.H. Desnoyer photograph.)

Three

GO THE
MOTOR COACH WAY

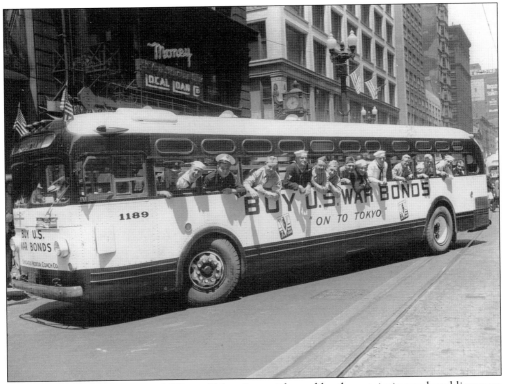

The war in Europe is over and "On to Tokyo," as evidenced by the patriotic war bond livery on Bus No. 1189. The 1940s would bring the motor coach to its highest standards. The streamline design of Yellow Coach (GM) No. 1189, built in 1942, was the most beautiful bus in the world. By the end of the 1940s, the motor coach would have an entire fleet of these buses. (*Chicago Tribune* photograph, Bruce G. Moffat Collection.)

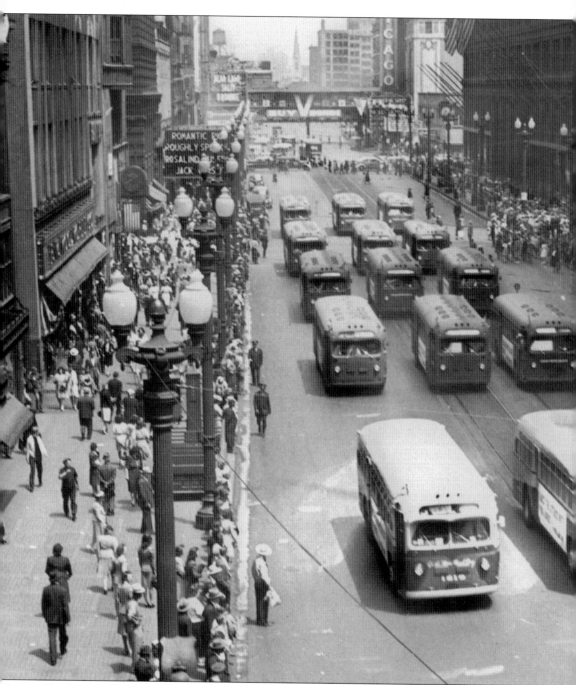

The first new buses for the motor coach since 1942 are seen southbound on State Street during a parade at Madison Street on June 27, 1945, two months before the war ended. This 75-bus order was allocated by the ODT and delivered in reddish-brown primer. As paint supplies became available, they would be painted in the motor coach livery. "On State Street that great street I'll show you around," is from the song "That Toddlin' Town," written by Fred Fischer in 1922. Later, it was made famous by Frank Sinatra and renamed "Chicago." A great street it is because of Potter Palmer. In the late 1860s, Palmer, a developer, was responsible for efforts in transforming State

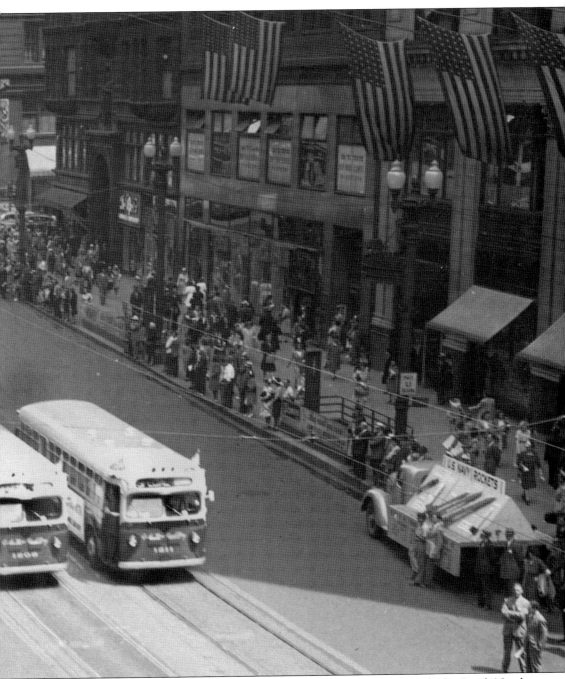

Street into a mercantile district. At the time, Lake Street and Market Street (today South-North Wacker Drive) were the primary mercantile districts. Palmer convinced Marshall Field and his partner, Levi Leiter, to move their department store, Field, Leiter & Company, to State Street and Washington Boulevard; from that point on, "that great street" was born. In the 1960s, State Street went into decline and became a pedestrian mall in 1979. It was reopened to street traffic in 1996 and re-gentrification began. (Herald American photograph, Bruce G. Moffat Collection.)

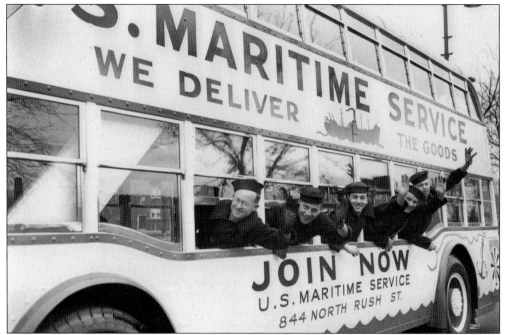

Members of the US Maritime Service Merchant Marines happily wave from a Chicago Motor Coach double-decker painted in a recruiting theme in 1943. Recruits were needed for the war effort, as thousands of new ships were built practically overnight. Service in the Merchant Marine was dangerous: 1 in 24 would be killed. Unfortunately, for 43 years after the war, they were denied government benefits. (Bruce G. Moffat Collection.)

Chicago Motor Coach No. 1189, a TD 4505 (transit diesel 45-passenger Model 05 bus), is shown here newly delivered from Yellow Coach at Pontiac, Michigan, in 1942. This series of 35 buses would be the last new buses for the motor coach until 1945. Painted in a patriotic livery, No. 1189 is taking part in a press event as part of a wartime bond drive. (Bruce G. Moffat Collection.)

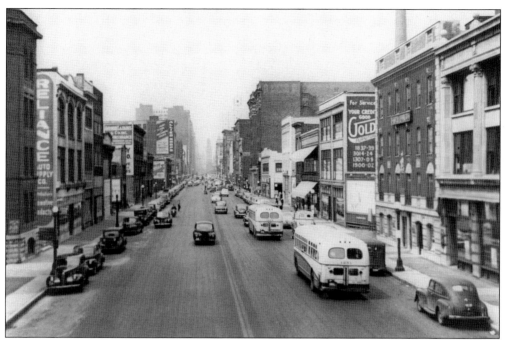

Racing north toward the Michigan Bridge, Nos. 1264 and 1251 have just passed under the St. Charles Air Line Railroad at 16th Street and Michigan Avenue in 1946. South Side buses did not enter the Chicago Loop but would terminate via Lake Street and Wabash Avenue into Wacker Drive at Michigan Avenue. The layover point was directly in front of the London Guarantee and Accident Building (CMC photograph, CTA Collection.)

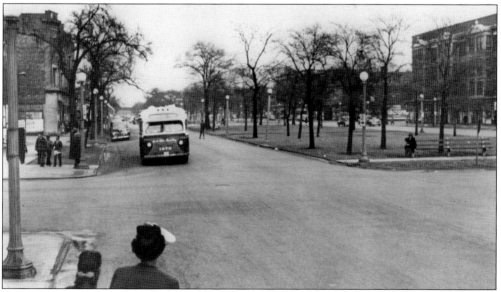

Looking east down Garfield Boulevard at Wabash Avenue is a Route 6 bus about to make a service stop at Wabash Avenue in 1946. It was motor coach policy to cross the intersection first before picking up passengers. The stop zone would have a pole with a motor coach stop sign affixed to it. No. 1276 will terminate its run at Trumbull Avenue at 3700 West 55th Street. (CMC photograph, CTA Collection.)

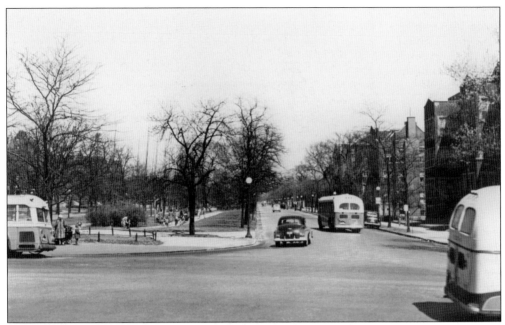

Looking north on Drexel Boulevard, 1500 East, from Hyde Park Boulevard, 5100 South, is a northbound No. 1 Drexel–Hyde Park diesel bus. The other buses are Route 2 Hyde Park buses. To the left is a Yellow 731 gasoline bus soon to be retired leaving the motor coach, an all-diesel operation, except for the double-deckers. Note the Park District streetlights lining the boulevard; at night, the street became magic. (CMC photograph, CTA Collection.)

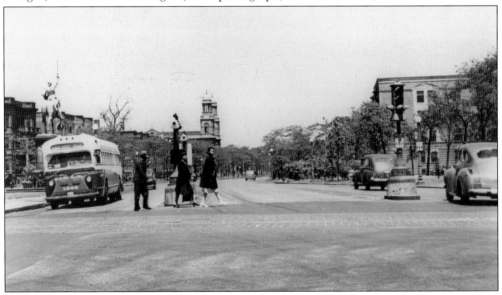

Chicago Motor Coach No. 1268 is shown here at Fifty-First and South Parkway southbound to 81st Street. This straight bus route would depart the Wacker and Michigan terminal to 24th Street, head east a few blocks, and turn into South Parkway. The motor coach had competition along the parkway with Jitney Cabs, to the point where the motor coach put on extra buses. They tried to hire Jitney Cab drivers but did not succeed. (CMC photograph, CTA Collection.)

Bus No. 1114, a Route 3 bus is in front of the Central Station at Roosevelt Road and Michigan Avenue in 1946. From here, the *Panama Limited* and the *City of New Orleans* shared the right-of-way with the Illinois Central electric suburban trains. As is written in a song by Steve Goodman, "I'm the train they call the City of New Orleans, I'll be gone 500 miles when the day is done." (CMC photograph, CTA Collection.)

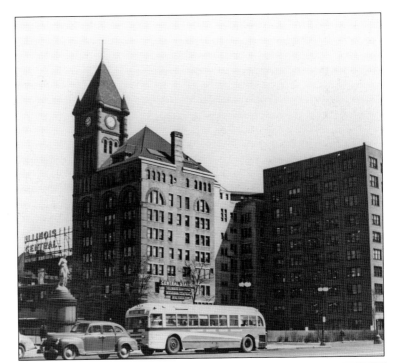

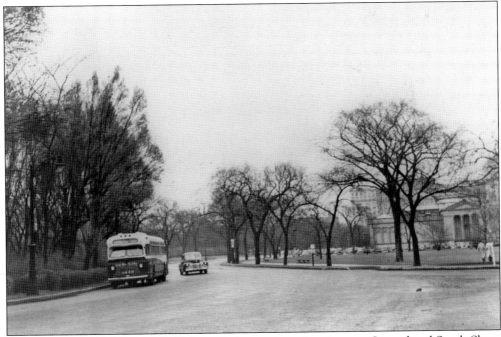

The Route 1 bus shown here in Jackson Park is outbound to Seventy-Second and South Shore Drive in 1946. The Museum of Science and Industry, pictured in the background, was the only permanent building of the 1893 World's Colombian Exposition. It housed what would become the Field Museum until 1920. With the exterior recast in limestone and the interior Art Moderne, the Museum of Science and Industry opened during the 1933 Century of Progress. (CMC photograph, CTA Collection.)

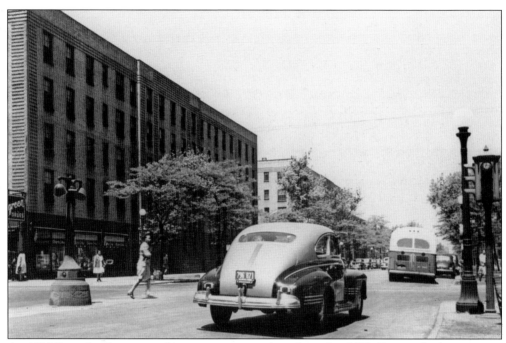

An 1100 Series bus has just made a service stop on the other side of 47th Street, which was motor coach practice, on Michigan Avenue. The bus is operating on either Route 10 Marquette Road or Route 6 Garfield Boulevard. During manufacturing of these buses, Yellow Coach changed its transit bus design so the last 25 of the 80-bus order would be delivered in the new streamliner Art Deco design. (CMC photograph, CTA Collection.)

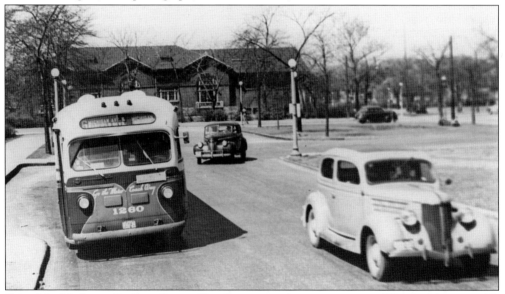

Signed for Michigan Bridge, a Route 6 bus has just made a service stop at Western Avenue with Gage Park in the background. The automobile pulling onto Garfield Boulevard is coming off Western Boulevard. Why the two streets? Streetcars not allowed on boulevards created this dual-street situation, and both streets ran parallel for three miles. To the far right, this wide boulevard ends and 55th Street starts. (CMC photograph, CTA Collection.)

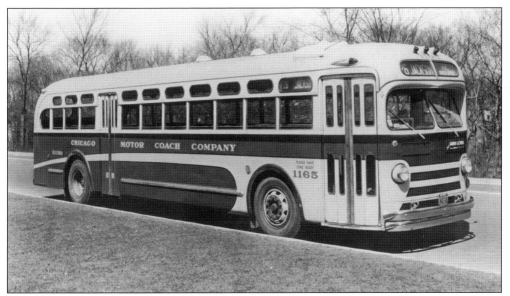

Chicago Motor Coach No. 1165, in this 1941 photograph, was part of the last 25 buses in an 80-bus order. During manufacturing, Yellow changed its bus design, so the motor coach took the last 25 buses in the new streamlined design. Note the Yellow Coach logo below the front window. This would indeed be the most beautiful bus that Yellow would ever design. Another 25 buses would be delivered in 1942. (CMC photograph, CTA Collection.)

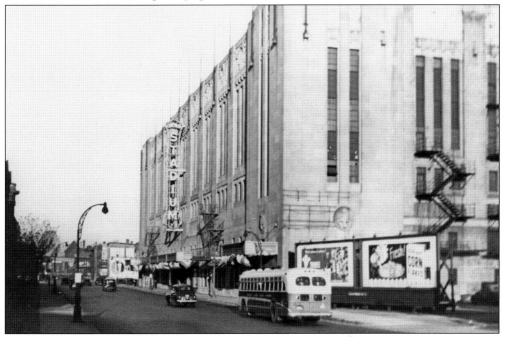

An 1100 Series bus on Route 31 Washington Boulevard is passing the Chicago Stadium on 1800 West Warren Boulevard and is the only West Division bus that will terminate at the Michigan Bridge. Opened on March 29, 1929, and closed September 9, 1991, the Chicago Stadium was the largest indoor arena in the world. President Roosevelt made his first mention of the New Deal in a speech there in 1933. (CMC photograph, CTA Collection.)

INSTRUCTIONS TO DRIVERS
on the Correct Method of
PREPARING, CHECKING, AND RE-PUNCHING
INTERCOMPANY TRANSFERS

Transportation Department

CHICAGO MOTOR COACH COMPANY

4221 West Diversey Parkway

January, 1944

This training manual was developed to ensure that CMC bus drivers knew how to read and punch time transfers to the Chicago Surface Lines and the Chicago Rapid Transit Company, the "L." Transferring from motor coach to motor coach had a separate transfer. One could ride in one continuous direction or transfer to the left or right, but could not use the transfer in reverse. The transfer would also be punched for a limited time. (John F. Doyle Collection.)

Clock transfers like the one pictured at right, front and back, were also used for the "L"; pastel green to the "L" and pink to streetcars or buses of the Chicago Surface Lines. The Chicago Motor Coach bus driver's hat badge (below, left) and inspector's badge (below, right) adorned the uniforms of CMC employees. (All, John F. Doyle Collection.)

STAMP HERE

W E

31 · WASHINGTON

JULY 4

G E

011146

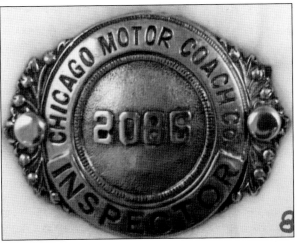

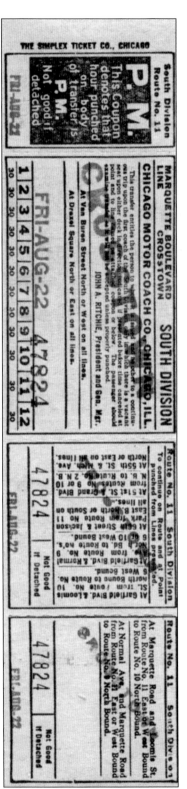
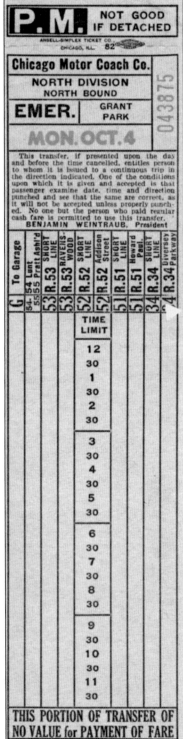

This Chicago Motor Coach South Division transfer at left is an earlier type that was issued by the bus conductor. The Chicago Motor Coach North Division time transfer at right was issued after one-man bus operation. (Both, John F. Doyle Collection.)

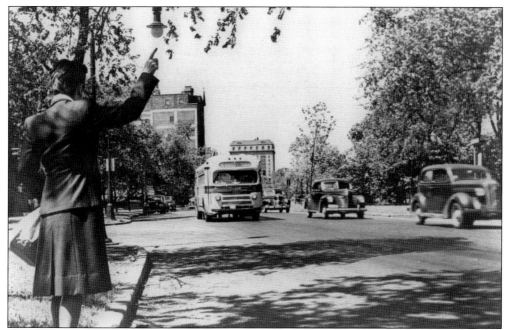

In this view looking north, a Route 36 Douglas bus is being flagged down by a well-dressed lady on Hamlin Boulevard near Gladys Street in Garfield Park. Route 36 will pass through Douglas Park and end its run at State Street and Jackson Boulevard going around the block at Dearborn and Quincy Streets. On the return trip, Route 36 will terminate at Fulton Street and Hamlin Boulevard, one block north of the Garfield Park Conservatory. (CMC photograph, CTA Collection.)

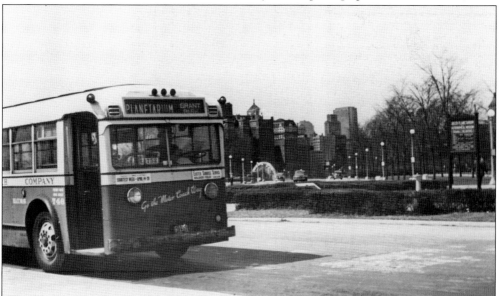

Chicago Motor Coach No. 746, the last of the gasoline single-deck buses soon to be retired, is working a Grant Park shuttle service. It is shown here on Leif Erickson Drive in front of the Field Museum. Leif Erickson Drive is now South Lake Shore Drive. The 700 Series buses were worn out after 10 years of service, which included 4 years of wartime service. They soon would be replaced with new diesels. (CMC photograph, CTA Collection.)

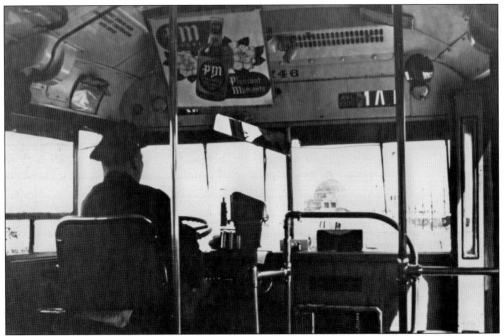

The interior of Bus No. 746 clearly shows the dime fare register. The device attached is to manually ring up and register the half-fares. The driver's money changer can also be seen. To the right of the bottom of the fare register is the transfer holder for motor coach tear-off time transfers only. The idling bus on Achsah Bond Drive is facing the planetarium. (CMC photograph, CTA Collection.)

In April 1946, Bus No. 871 would operate from North Avenue (Chicago city limits) along Austin Boulevard to Cicero city limits. This busy short line would connect with motor coach routes 31 and 26, the Lake Street and Douglas Park "L" and streetcar lines of both the Chicago Surface Lines and the Chicago and West Town Railways. Austin Boulevard was the dividing line for the full length of the route between Chicago and Oak Park. (CMC photograph, CTA Collection.)

A West Division bus is passing St. Thomas Aquinas Catholic Church and school at 4301 West Washington Boulevard, outbound in May 1946. The church parish began in 1909 for Irish Catholic immigrants. By 1925, this Tudor Gothic church would be built. Closed in 1992, it would later be rededicated as St. Martin de Porres Catholic Church. The fare for the students in 1946 was 5¢, transfer included. (CMC photograph, CTA Collection.)

Washington Boulevard takes a squiggle turn between Laramie and Leamington Avenues (5200 West). We see an inbound Route 36 bus straightening itself out while passing St. Thomas Aquinas Catholic Church. Bus No. 1148 was in a group of 25 buses built by Yellow Coach in 1940 and would be the most modern bus in the world. Thousands of this type would be manufactured. (CMC photograph, CTA Collection.)

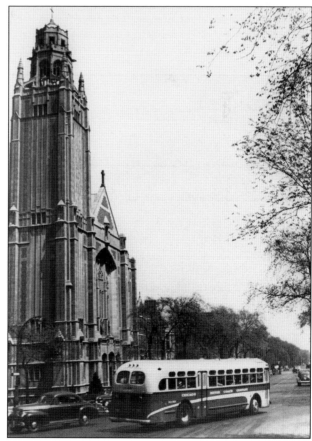

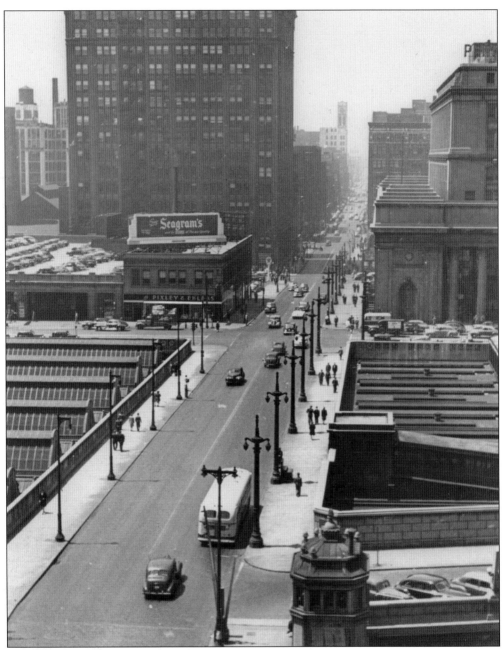

Looking west down Jackson Boulevard at the Chicago River is a West Division bus making a service stop. Also seen are the glass-roof sheds over the tracks for the passenger trains below at Union Station. In the background is a Pixley & Ehlers's restaurant. Their specialty was Boston Baked Beans for 15¢. Their 15 establishments were often called "greasy spoons." They appeared to never close, and the food was inexpensive. (CMC photograph, CTA Collection.)

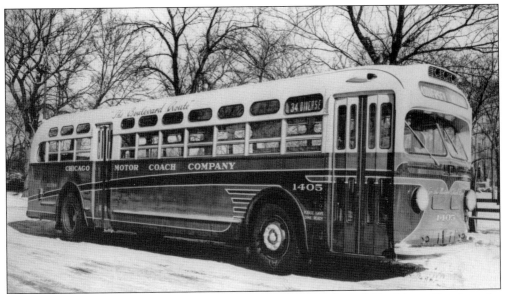

On a snowy winter day, the author and his friend Santo Racelli took the Motor Coach to the Lincoln Park Zoo to go sledding. After a few good runs, "alas," 10 big kids appeared at the top of the hill ready to start a fight. Just in time, the bus was arriving. With "our new friends" in hot pursuit, the driver opened the doors and two boys were saved from the "monsters of Lincoln Park." (Railway Negative Exchange, Barney Neuberger Collection.)

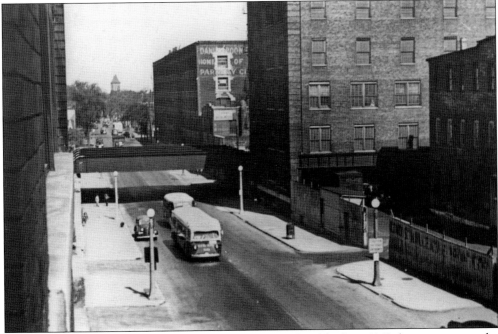

Chicago Motor Coach No. 1181, a 45-passenger transit diesel built in 1942, has just gone under the viaduct of the Chicago & Northwestern Railway. The bus is eastbound at 1600 West Diversey Parkway and is between Wolcott and Paulina Streets. Running inbound, No. 1181 will terminate in the Chicago Loop at State and Adams Streets. At that point, the run will turn north on State Street and begin the return trip. (CMC photograph, CTA Collection.)

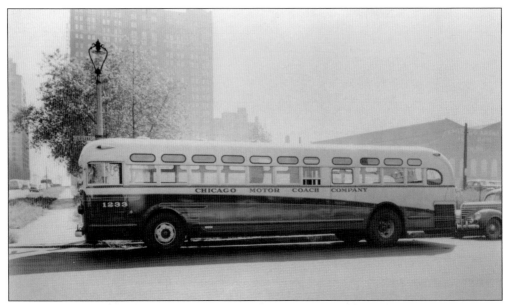

Bus No. 1233 is at Fairbanks and Huron in 1946. This group of TD-4506 buses (transit diesel 45-passenger Model 6) would be the first Motor Coach bus to carry the GM name. John Hertz sold the remaining Yellow Coach stock to GM in 1943. After that date, buses would display the name General Motors Truck and Coach Division. John Hertz also held a seat on the General Motors board. (Barney Neuberger Collection.)

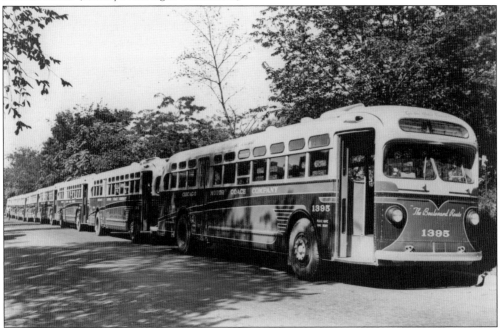

This 1946 order of new General Motors buses would retire most of the older equipment and were needed for the opening of two new routes: 4 Jeffrey in the South Division and 56 LaSalle-Wilson in the North Division. New to the point that their destination signs had not yet been installed, the buses also displayed a new paint design. Parked for a publicity photograph, the buses are across from the Ravenswood Garage. (CMC photograph, Barney Neuberger Collection.)

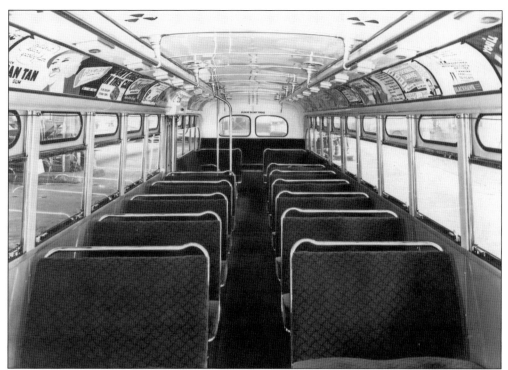

The interior of the new buses displays the handsome mohair seating, standard on motor coach equipment since 1935. The design would vary from a chevron to a weave and a plaid for the double-deckers that were in a two-tone green. The interior colors were a light-yellow cream and medium-forest green below the windows. Some series of buses would have a white cream interior instead of yellow cream. (CMC photograph, CTA Collection.)

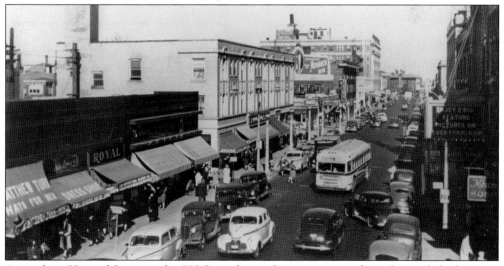

A very busy Howard Street as the 800 Series bus is about to open its doors for two lady shoppers. Howard Street is the dividing line between Evanston and Chicago. At this point, however, a small section of Chicago extends north of Howard Street a few blocks and east of Paulina and Haskins Street to the Lake. This 1946 photograph was taken from the Howard "L" platform at Paulina Street. (CMC photograph, CTA Collection.)

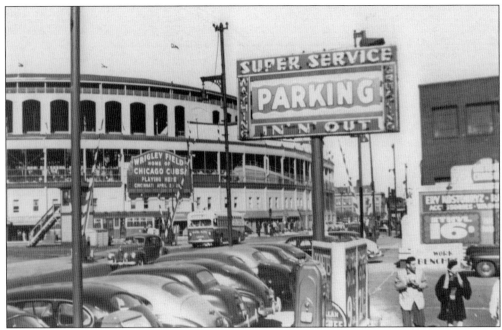

The motor coach also served Wrigley Field as a westbound 1200 signed Route 52 Addison to Pueblo is about to cross the Milwaukee Road Railroad tracks at Clark Street. In the background is a sedan Peter Witt streetcar on Route 22 Clark-Wentworth and barely seen in the far background is the Addison "L" station. The "L" was noted for its "Baseball Today" specials. Note the gasoline price: ethyl is 16¢. (CMC photograph, CTA Collection.)

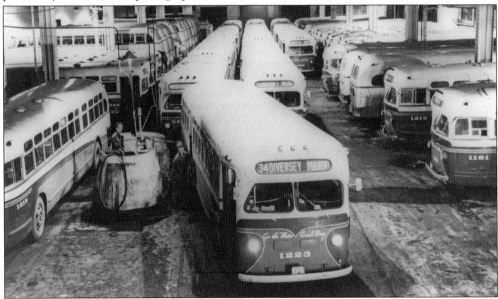

The night crew at the Keeler Garage, 4224 Diversey Avenue, is tasked with preparing the buses for the next day's service. Almost all of the motor coach equipment remained indoors when out of service and were very well maintained. As seen in the picture, the Keeler Garage also had its share of double-decker buses, which operated on Route 52 Addison. By 1950, Chicago double-deckers would be gone. (CMC photograph, CTA Collection.)

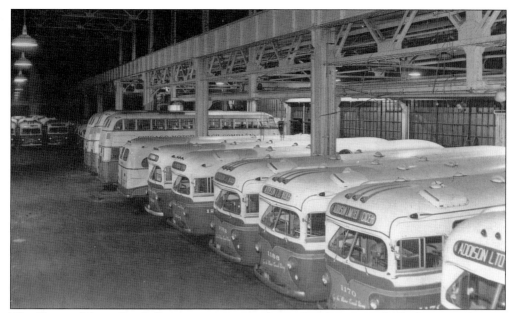

The Chicago Motor Coach Company went on strike on October 11, 1946. The buses can be seen here at the Keeler Garage parked for the duration. Low wages were the issue, just as they were in the strike of August 16, 1936, which turned violent. Bus driving was not an easy job. A day's work could begin at 6:00 a.m. and end at 7:00 p.m., with swing shifts (split) separating the hours worked without pay. (*Chicago Tribune* photograph, Bruce G. Moffat Collection.)

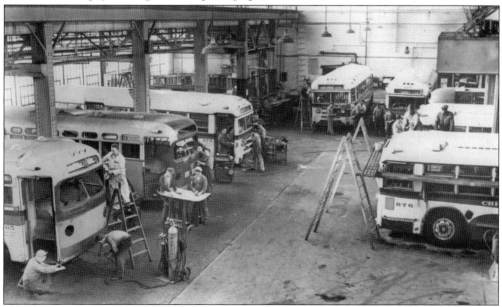

The Chicago Motor Coach equipment was always in excellent condition. The buses were repainted when necessary or when there would be a new paint scheme. Shown here in 1946 is the paint shop at the Keeler Garage, 4221 Diversey Avenue. Long before OSHA, these workers probably did not realize how unsafe working in a paint shop could be. There were no safety helmets or breathing protection. Unfortunately, safety standards for workers were a long way off. (CMC photograph, CTA Collection.)

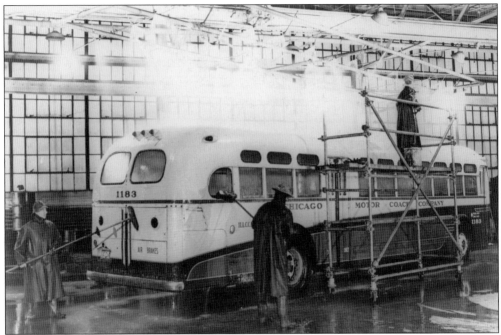

Pictured is the modern wash rack of the day: three human beings. Yellow Coach No. 1183, built in 1942, was already four years old in this picture, being washed at the Keeler Garage in 1946. The Art Deco paint livery on this bus was yellow cream, and the lower part was a grass green with a darker green with orange pinstriping. The motor coach always kept their equipment very clean. (CMC photograph, CTA Collection.)

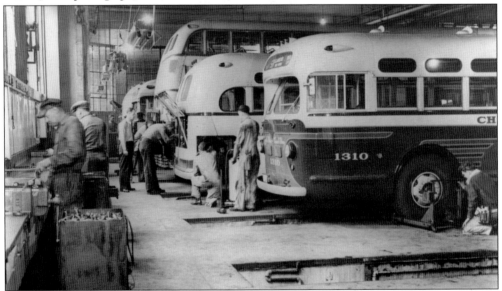

Two new 1300 Series buses are undergoing maintenance along with an 800 Series bus and a 1938 Yellow Coach double-decker at the Ravenswood Garage in 1946. Under what seems to be a watchful eye is a bus driver or line inspector, as he is in a uniform. Ravenswood housed a few double-deckers, since they had some Route 51 Sheridan Road runs out of that garage. (CMC photograph, CTA Collection.)

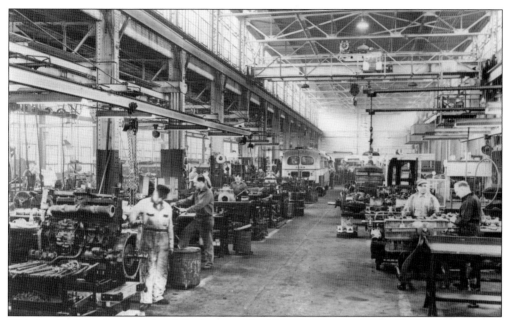

This is a look down the aisle of the engine rebuilding department at the Keeler Garage, 4221 Diversey Avenue. This large building was built as a boiler factory in 1922 and was purchased by the motor coach in 1933. The runs out of this garage were Route 52 Addison and Route 34 Diversey Parkway. The motor coach was completely self-sufficient and maintained the highest standard of maintenance possible. (CMC photograph, CTA Collection.)

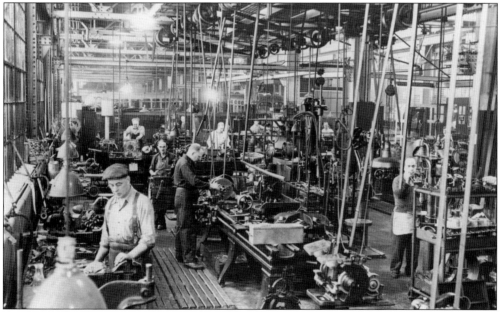

Busy doing their tasks, a few of the workers take the time to look toward the photographer in this view of the machine shop and workbench department at the Keeler Garage. They were skilled workers, and as evidenced by the machinery, their shops were state-of-the-art for that era. The noise must have been tremendous, but again, it was a different time. Ear protection had not yet arrived. (CMC photograph, CTA Collection.)

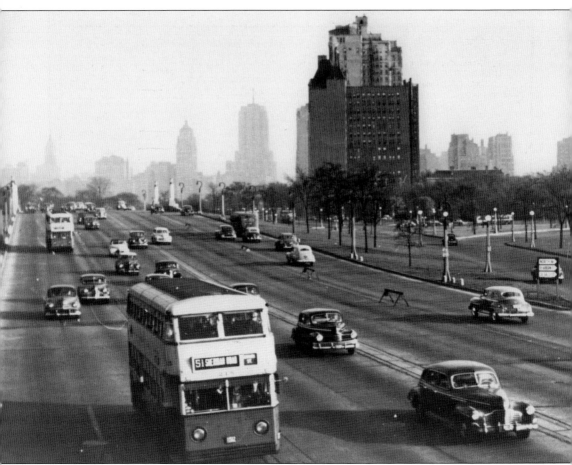

Chicago Motor Coach No. 215 entered Lake Shore Drive at North Boulevard for a short distance to Fullerton, then went through Lincoln Park on Cannon Drive and onto Sheridan Road at Diversey Parkway. The bus that follows is an Outer Drive Limited and will exit the Drive at Foster Avenue. The North and South Lake Shore Drives were connected by the Chicago River Bridge in 1937 and were 16 miles long. It runs from 6600 south at Jeffrey Boulevard and 5700 north at Hollywood. (CMC photograph, CTA Collection.)

Go the Motor Coach Way

This logo was created by the New York City Omnibus Corporation in 1935 and was used by the Chicago Motor Coach Company from 1936 until the Motor Coach was sold to the CTA in 1952. (Drawn by John F. Doyle.)

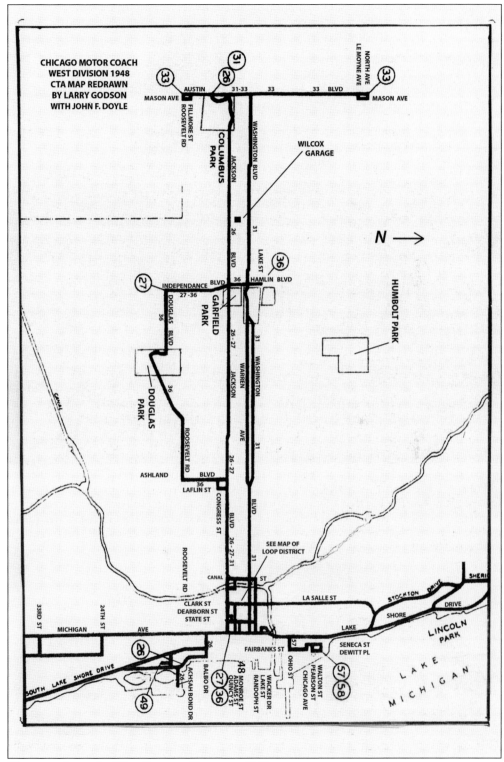

This map shows the West Division Routes in 1948.

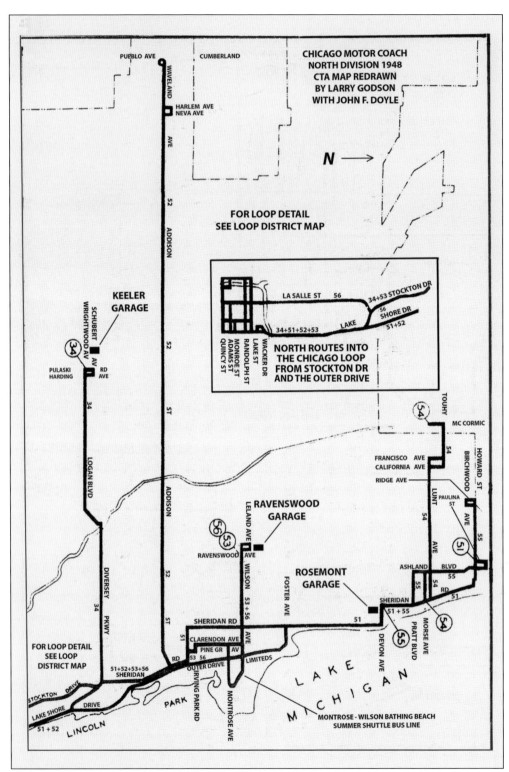

This map shows the North Division Routes in 1948.

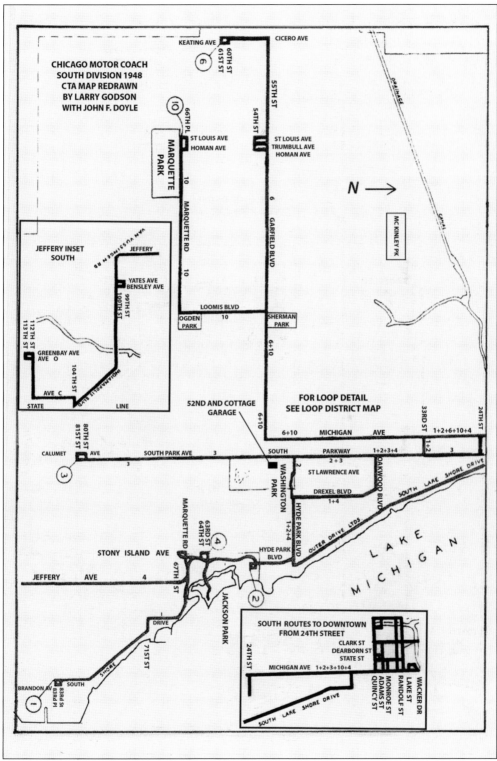

This map shows the South Division Routes in 1948.

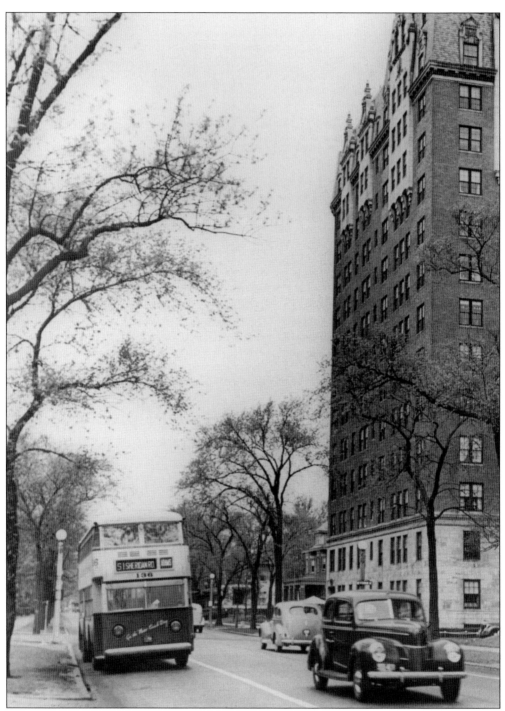

Southbound Chicago Motor Coach double-decker No. 136 was a gasoline bus. Only 40 of the double-deckers would be converted to diesel, No. 205 through No. 244 in 1941. Inbound to the South terminal at State and Adams Streets, No. 136 is at Glendale Avenue, 6200 North Sheridan Road with the lake less than a block to the right of this photograph. Nearby was the Glendale Avenue Park and Beach. (CMC photograph, CTA Collection.)

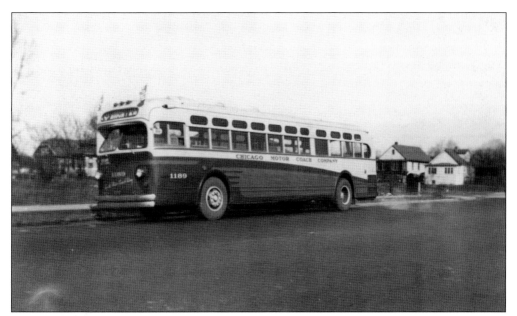

No. 1189 was part of a group of the last new buses that the motor coach would see until 1945. Shown here at Addison Street and Pueblo Avenue, on February 22, 1942, George Washington's birthday, the bus displays American flags to celebrate the holiday. Their new style of paint livery would be similar to the new buses in 1945. However, because of the war effort, those buses would operate in primer until the paint was available. (Donald Idarius photograph.)

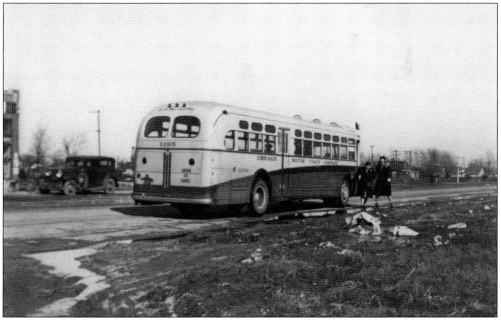

No. 1195 taken the same day, February 22, 1946, shows the melting snow and open spaces at the end of Route 52 Addison. This order of buses was in production when the war started, so they were delivered with full amenities, including double front chrome bumpers. All buses built after this would come under the Office of Defense Transportation (ODT) and would be allocated according to the war effort. (Donald Idarius photograph.)

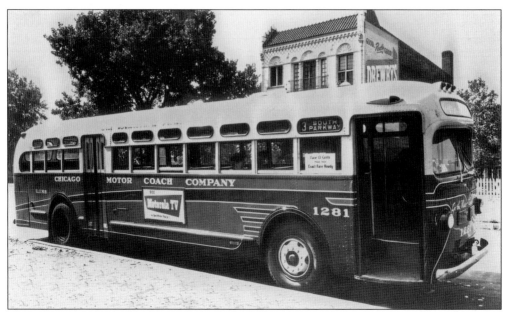

It is September 18, 1948, and the fare on the Chicago Motor Coach has just been raised to 13 cents after being one thin dime for 31 years. No. 1281 has been given the motor coach's new paint design, and the green and cream are topped off with a red stripe running around the bus on the belt rail just below the windows. No. 1281 is at the 81st Street and South Park terminal. (Barney Neuberger Collection.)

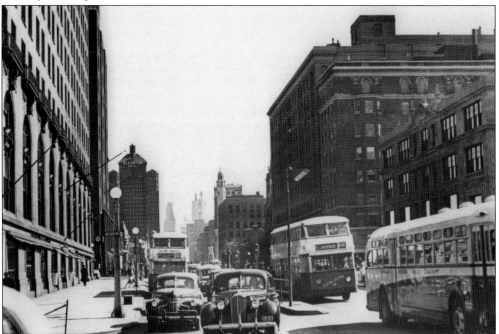

Looking south on Michigan Avenue at Oak Street in 1947 is Bus 131 taking the inner lanes in order to enter Lake Shore Drive and run express as an Outer Drive Limited to Foster Avenue. In the loading zone is a local 51 Sheridan Road bus following a new GMC transit diesel bus. To the left is the Drake Hotel, known for its famed Cape Cod Room. (CMC photograph, CTA Collection.)

One of ten Ford transits operated by the Chicago Motor Coach is shown here on Pratt Boulevard near Sheridan Road in 1946. These 27-passenger gas mechanical buses were Ford's answer to helping the war effort. Every company seemed to have some. Ford manufactured the chassis, and the bodies were constructed and assembled by the Union City Body Company of Union City, Indiana. They were delivered in 1944. (CMC photograph, CTA Collection.)

Chicago Motor Coach Company Ford transit No. 432 is picking up a passenger on Ashland Boulevard at Lunt Avenue in 1946. The bus is working the Route 55 Ashland-Howard short line, from Devon and Sheridan to Ashland, to Howard, and terminates at Ridge Boulevard. The Fords in August 1946 would be used on the new shuttles: Route No. 48 Monroe parking lot and Route No. 49 Soldier Field parking lot. (CMC photograph, CTA Collection.)

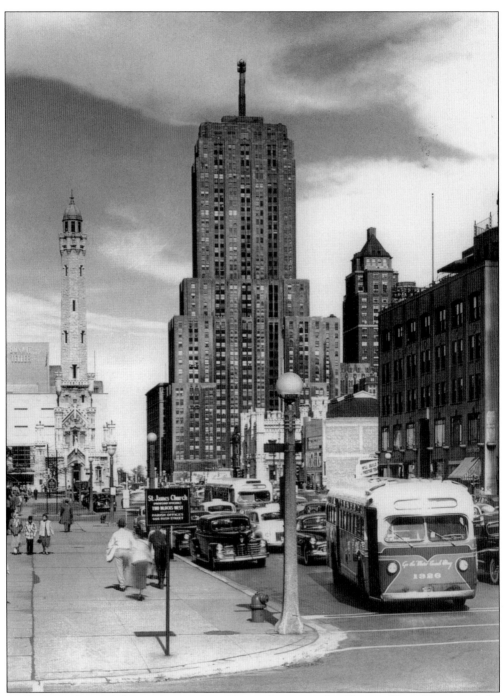

Looking north on Michigan Avenue from Huron Street are the Chicago Water Tower and the Lindbergh Beacon atop the Palmolive Building, later the Playboy Club. The year is 1947, when the famous real-estate developer Arthur Rubloff named Michigan Avenue, 13 blocks from the river to Oak Street, "the Magnificent Mile." And magnificent it was, along with buses of the Chicago Motor Coach Company, exclusively serving it. (Hendrich-Blessing Studio photograph, Alan Lind Collection.)

Four

THE BOULEVARD ROUTE

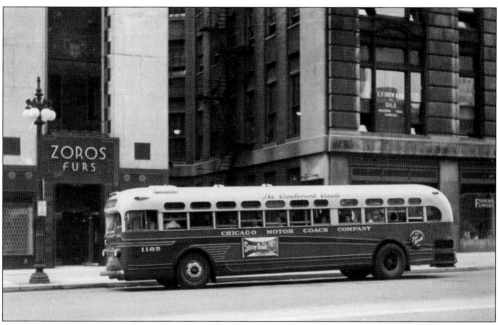

This chapter concludes the last few years the Chicago Motor Coach operated as an independent company. Bus No. 1185, illustrious in its new livery, is southbound on Michigan Avenue after crossing the Michigan Bridge at Wacker Drive. In bright red, "the Boulevard Route" script on the side of the bus was the motor coach's advertising. In the background are the London Guarantee and Accident Building and Zoros Furs. Today, the London Guarantee Building is a hotel. (CTA photograph.)

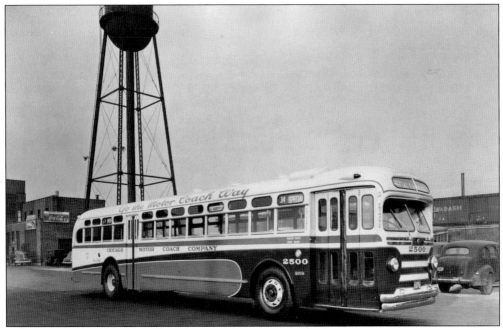

This handsome bus No. 2500 was built by Yellow Coach in 1940 as an experimental bus. It was a 54-passenger transit diesel. Having just been repainted at the Keeler Garage in 1946, the bus was put on trial and testing proved positive. In 1948, Chicago Motor Coach would receive 100 similar buses. Chicago would be the only property to order these long buses. (CMC photograph, CTA Collection.)

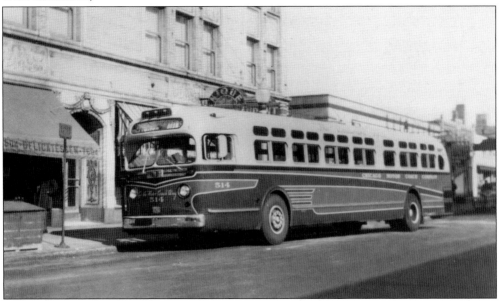

The replacement buses for the double-deckers would be delivered in 1948. They were designated by the builder as TDH 5502 (transit diesel hydraulic 55-passenger Model 2 bus). GM would never duplicate them again. Shown here at 7604 North Paulina Street waiting run time, the Unique Café, behind the bus, would be the perfect spot for the drivers to grab a fast lunch or a sandwich at the delicatessen. (CMC photograph, CTA Collection.)

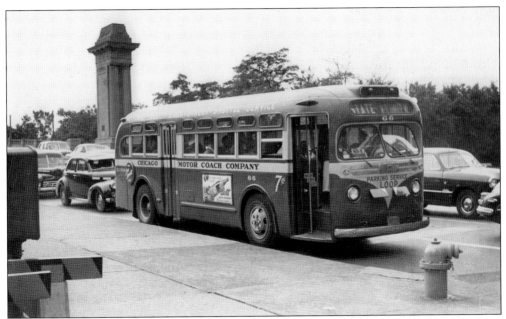

This 7¢ shuttle bus, No. 66, is on Balbo Drive at Michigan Avenue in 1950 in this view looking southeast. Chicago Motor Coach bus run No. 884 will turn north on Michigan Avenue then west on Van Buren Street to State Street. Working State Street north to Wacker Drive, the route will terminate across the Chicago River at the Merchandise Mart. The return trip to Soldier Field parking lot will follow the same route. (CTA photograph.)

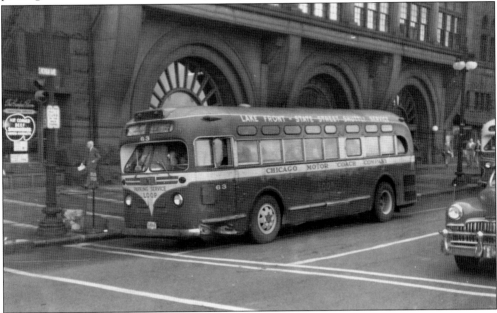

In 1947, twelve smaller 32-passenger GMC transit diesels were purchased for the North Side short lines but ended up in parking lot shuttle service. The buses were repainted in a distinct two-tone grey with a brilliant red roof and trim. In this 1950 photograph, the bus is in front of the Auditorium Theatre building designed by Louis Sullivan and Dankmar Adler in 1889. As a young apprentice, Frank Lloyd Wright was employed by the firm. (CMC photograph, CTA Collection.)

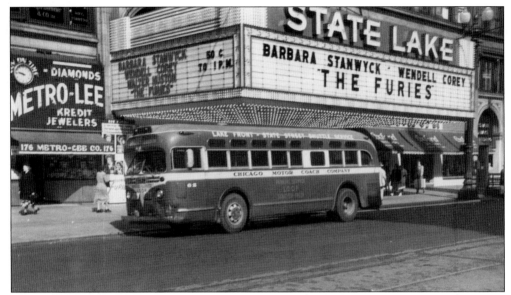

In 1950, bus No. 62 works State Street on the Route 49 shuttle service to Soldier Field. The State Lake Theater was built in 1919 as a vaudeville house and, in 1938, became part of the Balaban and Katz theater chain. Closed in 1985, it was gutted and converted into WLS-TV studios. Later, the front was restored to its original design without the marquee and ticket booth. (CMC photograph, CTA Collection.)

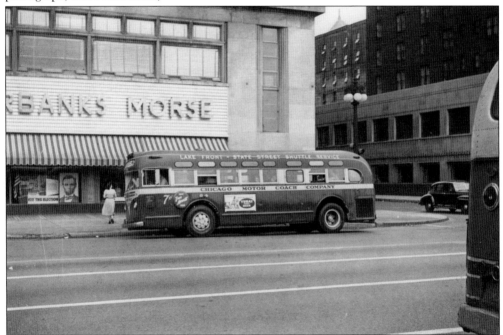

In 1951, Chicago Motor Coach No. 64 discharges a lady rider at Harrison and Michigan Avenue, 600 south. Although used for the parking lots, the buses also did local pick-ups along their routes. They were quite the "people movers" for short runs in the business district and to the museums. The Fairbanks Morse building may have been a sales office. Among their products, Fairbanks Morse built diesel locomotives until 1958. (CTA photograph.)

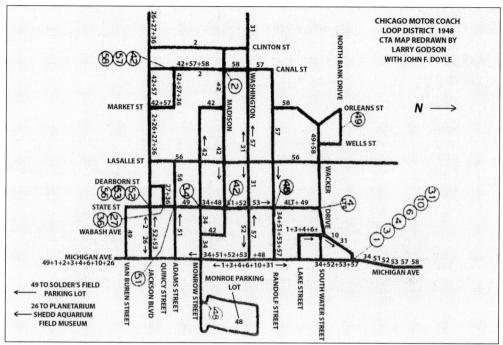

This map shows the Downtown District in 1948.

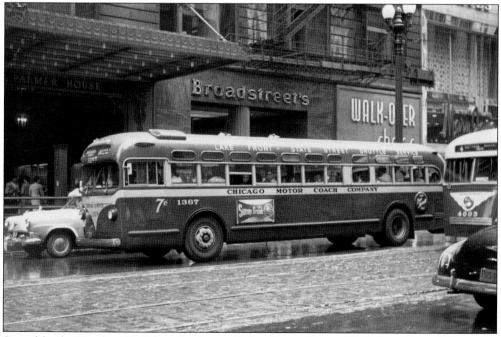

Signed for the Merchandise Mart, this Route 49 shuttle is in front of the Palmer House Hilton on a rainy Chicago Day in 1952. Potter Palmer built his first hotel on this spot opening in October 1871 only to see it burn to the ground 13 days later in the Chicago fire. A new Palmer House Hotel rose on this site in 1922. Conrad Hilton purchased the Palmer House in 1945. (CTA photograph.)

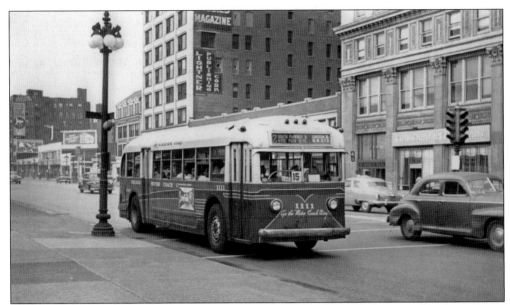

Northbound bus No. 1111 built by Yellow Coach at Pontiac, Michigan in 1939 sports the new Motor Coach paint design and is at Ninth Street and Michigan Avenue. On June 25, 1951, the Route 2-Hyde Park was rerouted from its Michigan Bridge terminal to serve Union Station and the Northwestern Station. Also evident is the November 6, 1951, fare increase to 15¢, the last increase for the motor coach. (CTA photograph.)

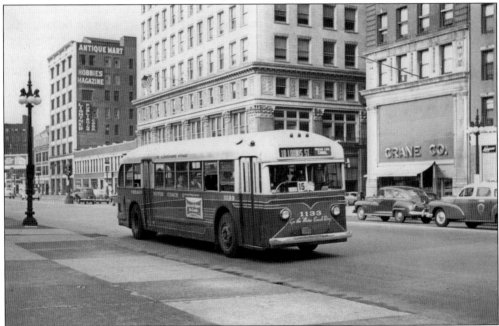

Chicago Motor Coach Route No. 10 Loomis has also been rerouted away from its Michigan Bridge terminal to Canal and Washington Streets at Union Station in an attempt to increase ridership. Across the street at 836 South Michigan Avenue is the Crane Company Building, a steel-frame skyscraper built in 1912. Designed by Holabird and Roche, this Classical Revival building is 12 stories high and is in the National Register of Historic Places. (CTA photograph.)

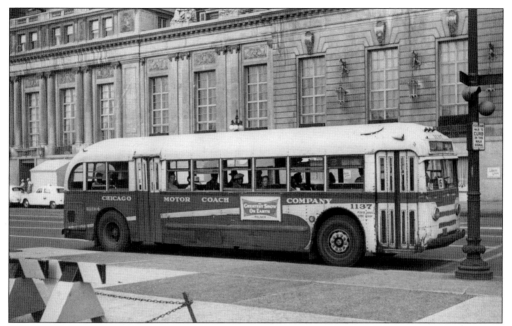

Bus No. 1137, looking a bit tired in its 1939 livery, is at Balbo Drive and Michigan Avenue in 1951. In the same year, the Stevens Hotel across the street was renamed the Conrad Hilton Chicago. Opening May 12, 1927, this 3,000-room hotel ended in receivership after the Stevens family went bankrupt. Purchased by the US Army in 1942, it sold again in 1945 to Conrad Hilton, who purchased it for $7.35 million. (CTA photograph.)

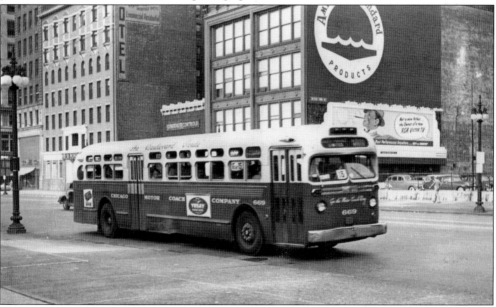

Bus No. 669 was part of the last group of buses purchased by the motor coach. The buses were built in 1950–1951. The "Hotel" building in the background at 830 South Michigan Avenue was built for the Young Women's Christian Association in 1893. The building was a haven for unchaperoned women coming to Chicago. In 1929, it became the 830 Michigan Hotel. In 2010, it was demolished leaving the site vacant. (CTA photograph.)

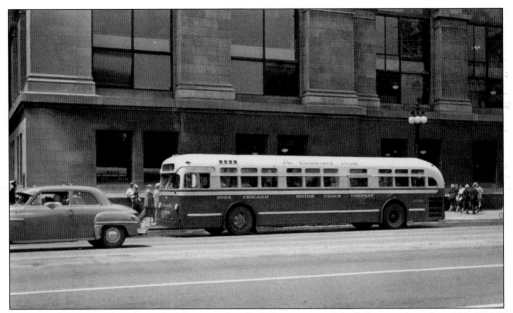

In 1951, the motor coach took delivery of eight 50-passenger Mack buses. Another 100 GMC buses, the 700 Series, were on order; however, the motor coach canceled the order when they realized they would be selling to the CTA. The Chicago Public Library opening in 1897 is in the background. This Academic Classical–style building is now the Chicago Cultural Center. (CTA photograph.)

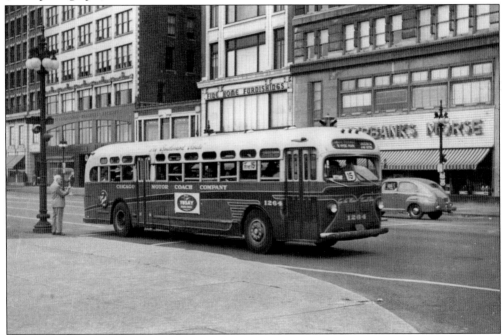

Chicago Motor Coach No. 1264 was part of the first delivery of new buses in the last few months of the war; it was the basic equipment the motor coach would use until the CTA purchase. Already in its second paint scheme, the next time No. 1264 is painted it will be as a CTA bus. Notice the International Business Machines (IBM) building in the background. (CTA photograph.)

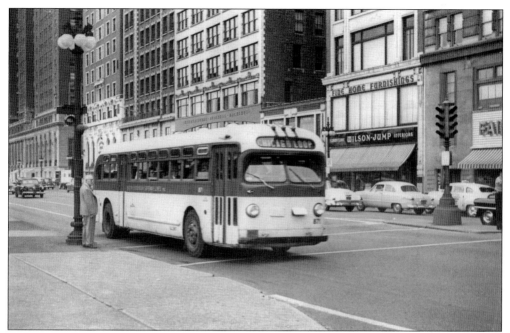

South Suburban Safeway Lines Inc. No. 871 is shown here at Harrison and Michigan Avenues in 1951. Safeway was a suburban carrier and would share Michigan Avenue and South Park with the Motor Coach. Bus No. 871 will terminate its Chicago Loop run at the Trailways Bus Depot at 20 East Randolph near Wabash. Safeway was affiliated with Trailways using their red and cream paint colors and Hobo font script. (CTA photograph.)

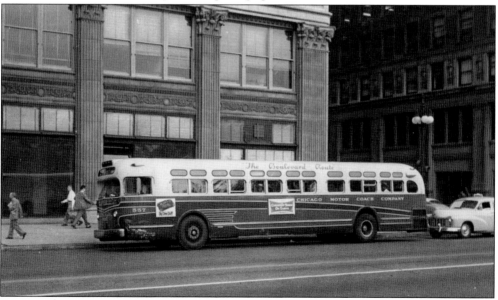

Bus No. 557 would be part of a 100-bus order, which would be the largest bus General Motors would ever produce. Basically purchased in 1948 as future replacements for the double-deckers, the buses had double front doors and seated 55 passengers, compared to 45 passengers on standard equipment. No. 557 is shown here in front of the Standard Oil Building at 910 South Michigan Avenue. (CTA photograph.)

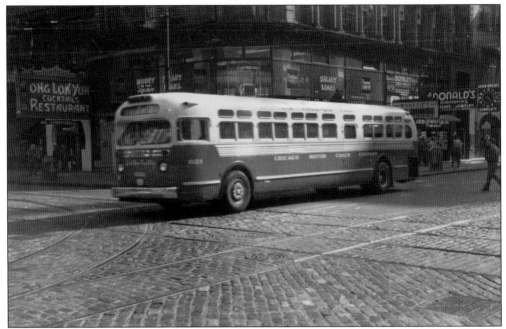

The last series of buses purchased by the motor coach were Nos. 601 through 700, would seat 51 passengers, and were a wider bus. No. 621 is shown here crossing Dearborn Street westbound on Washington Boulevard in 1951. The Ong Lok Yun Restaurant brings to mind beef chop suey with rice and hot tea. The building was the McCarthy Building. An attempt was made to save it, but it was torn down. (CTA photograph.)

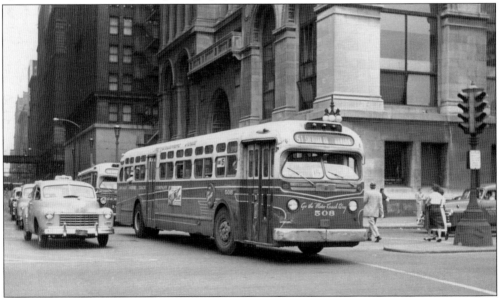

Bus No. 508, the longest bus that General Motors ever made, is turning into Michigan Avenue for its long run northbound to Howard and Paulina Streets. One can see the larger doors to match the width of the doors on the double-deckers. At this time, the double-deckers had been gone for a year. A Route 34 Diversey Parkway bus is following and will terminate on Wrightwood Avenue at Pulaski Road. (CTA photograph.)

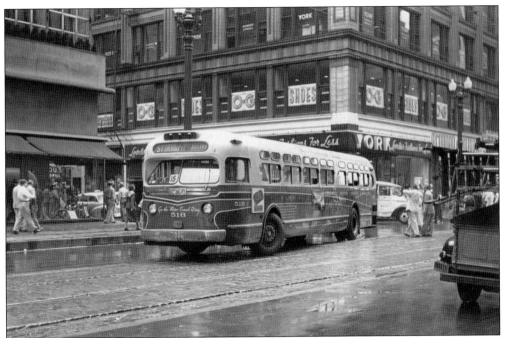

One of the long 500 Series' run, No. 25, turns north into State Street from Adams in 1951. A rainy summer day will not keep the ladies away from buying a new pair of shoes at O'Connor and Goldberg in the Republic Building at 209 State Street. The building, which opened in 1905, was designed by Holabird and Roche. John O'Conner and Julius Goldberg started selling ladies' shoes in the early 1900s. (CTA photograph.)

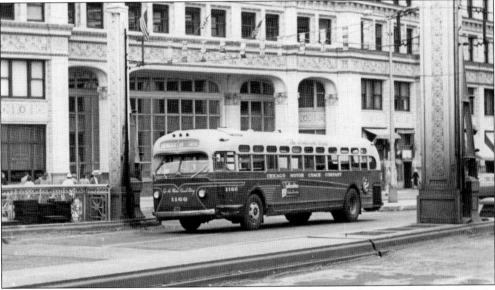

A Route 58 bus is heading for the train depots and is crossing the Michigan Bridge in 1951. In the background is the Wrigley Building. In 1892, William Wrigley Jr. had a soap and baking powder company and gave away gum as an incentive. Eventually, the demand for gum surpassed his other products. His son Philip K. Wrigley donated the entire wartime production of gum to the Armed Forces. (CTA photograph.)

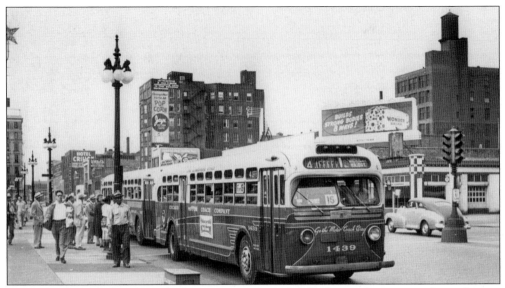

Bus No. 1439, one of 40 buses built in 1947–1948 to New York specifications, is shown here at 11 Place East pulling away from the bus stop in 1951. Signed for Route 4 Jeffrey, the route will terminate at Michigan Bridge. The billboards and advertisement paintings showed products of the day. The author worked for Butternut Bread for 40 years; his biggest competitor was Wonder Bread. (CTA photograph.)

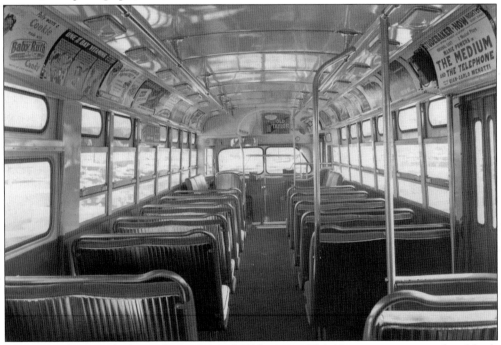

This 1947 photograph shows the interior of 1405, a new GM 44-passenger transit diesel built to New York City specifications. It was diverted to Chicago because of a bus shortage. Instead of having mohair seats, these buses would be the first motor coach buses with leatherette seats. Short window openings and the protection bar around the driver would make these buses unique. (GM photograph.)

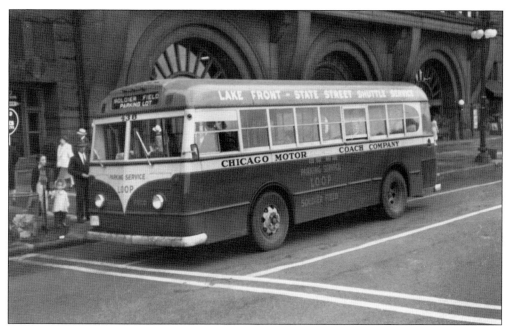

The driver of this Ford Transit 438 is engaging in conversation regarding directions with a likely passenger in front of the Auditorium Theatre in 1950. Possibly, the Art Nouveau treasure in the background was often overlooked as passengers boarded their bus. Completed in 1889, the Auditorium Theatre was the first mixed-use structure in the country consisting of an office block, a hotel, a restaurant, and the awesome Auditorium Theatre. (CMC photograph, CTA Collection.)

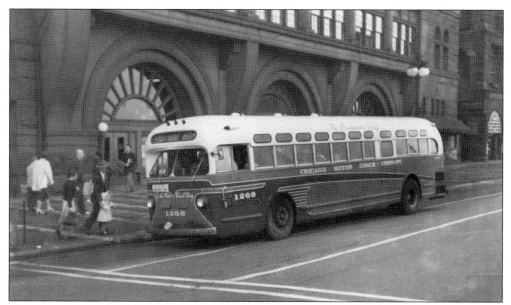

The passengers in the above photograph apparently were given information from the Ford Transit bus driver to take a Route 3 South Parkway bus; they are now boarding bus No. 1266. Note the faulty air vent below the driver's compartment. Newspapers left on the bus were used to plug the leaks; especially annoying were leaks around the driver's windshield where a pinhole could feel like a tornado on one's head. (CMC photograph, CTA Collection.)

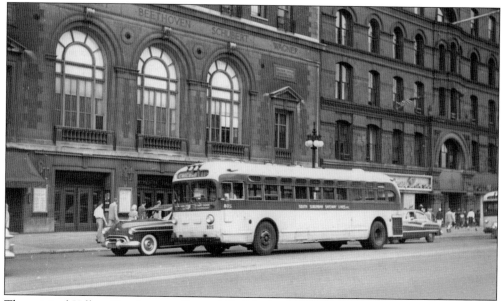

The original Yellow Coach streamliner of 1941 had a flat windshield like the South Suburban Safeway Lines bus in this 1951 photograph. Yellow Coach would invent the standee window, and St. Louis Car Company, in conjunction with St. Louis Public Service, invented the inclined windshield. The companies traded the rights, and afterward, all Yellows received the inclined windshield. A windshield conversion kit was available but was not used on No. 805. (CTA photograph.)

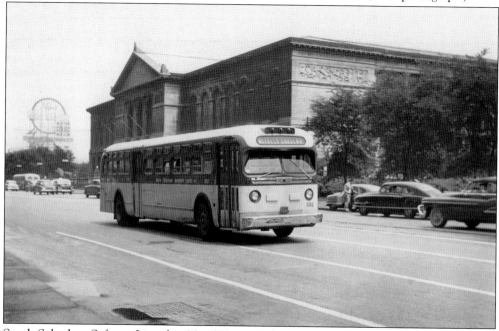

South Suburban Safeway Lines bus No. 502 passes the Art Institute of Chicago southbound in 1951. This excellent bus company, owned by Paul O. Ditmar, served the South Chicago suburbs and shared South Parkway with the motor coach. One could board a Safeway bus outbound but could not be let off until 83rd Street, two blocks beyond the 81st Street motor coach terminal. Inbound, the pattern would reverse, with no passengers boarding after 83rd Street. (CTA photograph.)

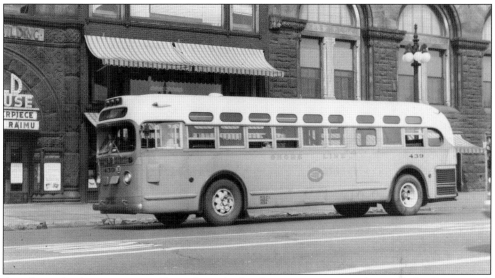

Another suburban company, Shore Line, had a downtown route and served the Hammond, Whiting, and East Chicago areas of Northwest Indiana. One of its buses is shown here passing the World's Playhouse, 408 South Michigan Avenue, and the Chicago Club in 1951. Shore Line, originally a streetcar operation, converted to buses in 1940 and had their main terminal at 63rd Place and South Park Avenue. It connected with the "L" and the White City Amusement Park until it closed in 1933. (CTA photograph.)

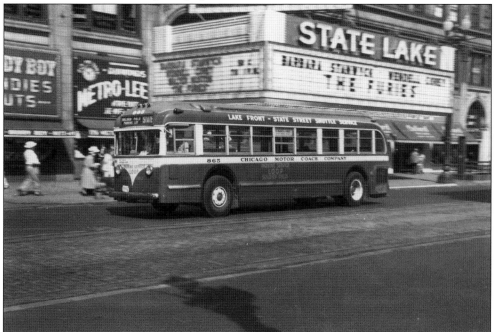

The Chicago Motor Coach used a variety of equipment on their Soldier Field and Monroe parking lot shuttle routes. Bus 800 is southbound on State Street in the summer of 1950. On the front of the bus is advertising for the Chicago Fair, which followed the 1948–1949 Railroad Fair. The theme of the Chicago Fair highlighted advancements in industry, science, and agriculture influenced by our nation's pioneering spirit. (CTA photograph.)

This North Division supervisor is at his checkpoint at Chicago and Michigan Avenues in 1951. His role is to assure that all buses are adhering to their schedules. He may also reroute buses because of problems on the route ahead. The supervisor also had the authority to "short turn" buses, or remove them from the system, to alleviate congestion. (CTA photograph.)

It is hard to believe, but in 1951, there were still empty lots on the Magnificent Mile, as seen to the right of this picture occupied by billboards. Note the standard motor coach bus stop sign painted grass green with yellow-cream letters affixed to a black pole. Looking north down Michigan Avenue toward Pearson Street, bus No. 545 is about to pull away after being checked. (CTA photograph.)

With the historic Chicago Water Tower in the background, the line inspector has his scheduling book in hand. The motor coach uniform was a grey-green with grass-green trim and silver buttons. A grey shirt and black tie were worn under the military-style tunic. The tunic with military pockets eventually gave way to the Eisenhower battle jacket, although some drivers wore the tunic to the end. (CTA photograph.)

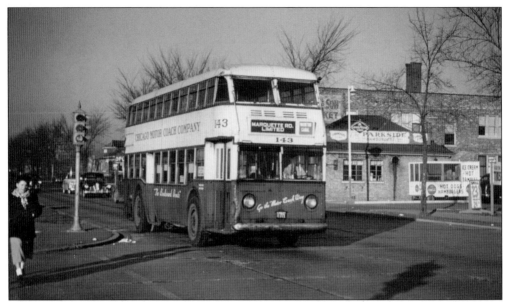

Chicago Motor Coach No. 143 is shown here outbound on Marquette Road at California Avenue on November 7, 1949. This 72-passenger gasoline bus was built by Yellow Coach in 1936, and by July 25, 1950, the last double-deck buses would be retired. In order to gain additional riders, the route was extended away from the Michigan Bridge terminal and went to Union Station at Canal and Washington Streets. Note gasoline was 23¢ per gallon. (William Hoffman photograph.)

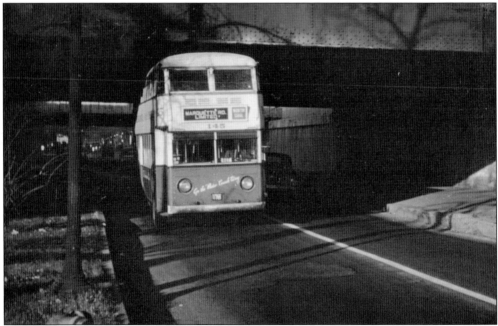

On November 8, 1949, bus No. 145 an eastbound Marquette Road Limited to Washington and Canal, is coming out of the long 67th Street viaduct of the Pennsylvania Railroad and the Baltimore & Ohio Railroad at Hamilton Street. Note that the destination reading on the motor coach was red with white letters. The route number and description would be in white letters on a black background. A Limited did not display route numbers. (William Hoffman photograph.)

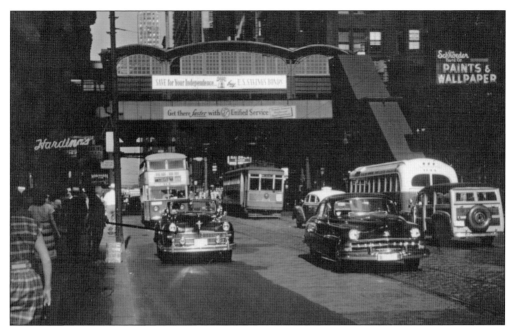

In this interesting photograph, is a Washington Boulevard Limited double-decker bus No. 114 outbound to Austin Boulevard and an inbound single-deck bus operating Route 31 in the opposite direction. In the middle of the scene is a former Chicago Surface Lines Pullman, built streetcar No. 602. It is on the Milwaukee Avenue car line; all are passing under the "L" tracks and the Wells Street Station on June 8, 1950. (William Hoffman photograph.)

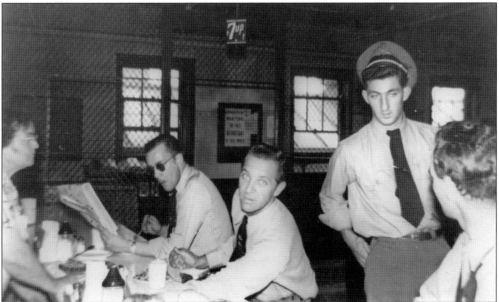

The bus drivers are enjoying a home-cooked meal at the second-floor lunchroom of the Rosemont Garage in 1950. Anna Mutschinsy operated the lunchroom at 1120 Rosemont Avenue. Many of the young drivers wanted to show off, like sailors of the era, their pompadour hairdos. By keeping the hat perched halfway back on their heads, they could flaunt their waves to the ladies. This young driver is obviously quite the show-off. (Henry Mutschinsy, Wonder Bread.)

Anna Mutschinsy is taking a break with her customers. Born in Wisconsin, she moved to Chicago with her son Henry, who went to work for Wonder Bread. The author worked for Butternut Bread; he and Henry were competitors on the Jewel Food Store account. Henry knew the author liked the Motor Coach and gave him three snapshots from his mother's restaurant. The author wishes Henry was here today to see this book. (Henry Mutschinsy, Wonder Bread.)

Bus drivers, like most transit workers, had long hours broken up by swing shifts. For example, a driver would report at 5:30 a.m. and work until 10:30 a.m., then return at 3:30 p.m., and drive until 6:45 p.m. There were various combinations of runs, picked by seniority. In the off hours, the drivers were on their own time. Anna Mutschinsy's restaurant was the perfect respite for the Motor Coach drivers. (Courtesy Henry Mutschinsy, Wonder Bread.)

Southbound No. 1411, run No. 284, pauses awaiting a passenger to depart alongside the Chicago Public Library. Although the bus will turn into the Loop at Adams Street, the driver already has his northbound destination set for Pulaski Road. Bus No. 1411, built in 1947–1948, was part of a 40-bus order built for New York but was diverted to Chicago because of two new bus routes opening in 1946. This photograph was taken shortly after the CTA purchase. (CTA photograph.)

This photograph was taken at the Ravenswood Garage three months before the motor coach was sold to the CTA. The author received the photograph 30 years ago at a CTA retirement luncheon. Looking at the scene from July 1952, the author remembers those faces well. The men were gathered for a final photograph knowing that the motor coach would soon be sold. (John F. Doyle Collection.)

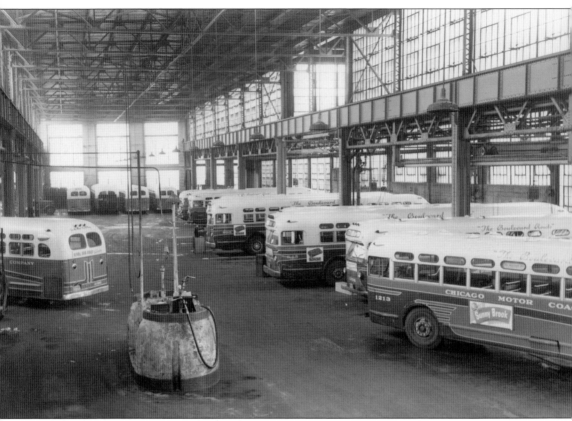

This photograph was taken on October 13, 1952, thirteen days after the motor coach was sold. On a sunny Sunday morning in 1948, the author and two buddies transferred to a new 500 signed for Addison-Pueblo at Lake Shore Drive. With the essence of a new bus, "the explorers" were on their way. Stepping off at Pueblo Avenue, three 10-year-old city boys found themselves standing in a prairie at the end of the world. Another fond memory of the author was a young bus driver just out of the Air Force. The driver would let the author stand next to him on a packed Wilson Avenue Outer Drive Limited and punch the driver's transfers. Going down the Outer Drive at full speed, this 10-year old boy was in bus heaven. The driver also taught the author the proper way to punch the transfers. The boy often wondered what the riders must have thought of this instructional situation. At the Ravenswood and Wilson Avenue Depot was a sweet shop where the drivers would stop for a snack. The driver would always buy his young fan a cherry Coke mixed fresh from the soda fountain. Seventy years later, that driver is still the author's hero. (CMC photograph, CTA Collection.)

Five

THE BOULEVARD DIVISION

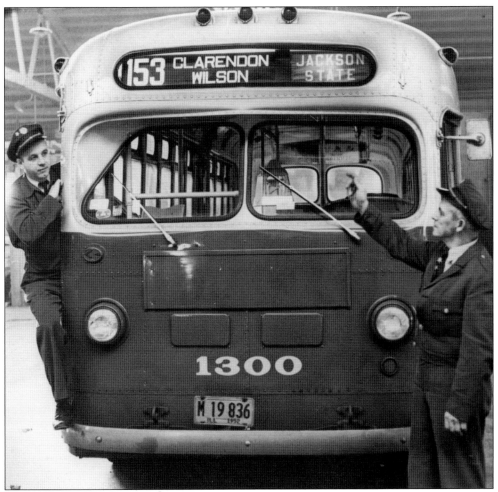

On September 30, 1952, the motor coach was sold to the CTA. At the Ravenswood Garage, veteran motor coach drivers Carl Nelson (left) and Harold Miller show off the first bus painted in the livery of the CTA. Because the CTA already had streetcar lines with the same route numbers as the motor coach, a "1" was put in front of the current number. (CTA photograph, Carl Nelson Collection.)

The sale of the CMC to the CTA took place on September 30, 1952, at the First National Bank of Chicago. Seated at the table, from left to right, are William McKenna, CTA secretary; Ralph Budd, CTA chairman (about to sign); Benjamin Weintraub, CMC president; Harry N. Wyatt, CMC secretary (standing); and Peter Meinarde, CTA comptroller. (CTA *Transit News* photograph.)

For a few years, the CTA would operate the former motor coach routes as the Boulevard Division because of employee and union issues. The transfer would be overseen by former motor coach management. In this photograph, from left to right, are Clyde North, assistant to comptroller; Elmer Swanson, purchasing agent; Andrew Forbes, superintendent of garages; Kay Lorentzen, traffic engineer; Joseph Gaynor, superintendent of transportation; and J.E. Anderson, claim agent. (CTA *Transit News* photograph.)

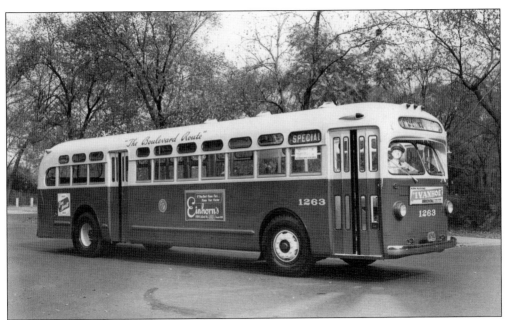

One of the first buses in the new CTA paint livery is shown here with former CMC (now CTA) driver Joe Lebrect. The driver still is wearing his motor coach uniform with a medium-gray shirt and black tie. The full uniform was gray tinted green with a Kelly-green hat braid and a thin stripe down the side of the trousers. Note the newly posted fare of 20¢, with token, 17¢. (CTA *Transit News* photograph.)

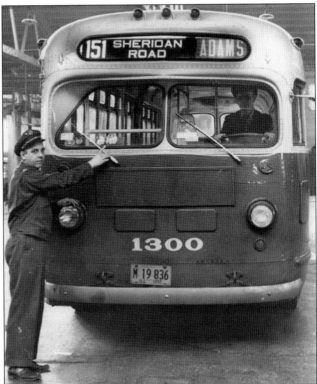

Carl Nelson was a Motor Coach/CTA driver. The author met Carl Nelson at a Marine Corps League meeting around 1980. Carl was a World War II combat Marine. He told me that he remembered two boys that boarded his bus many times at Dover and Wilson. Those two boys were Jackie and Tommy Doyle. There were so many drivers that the author could not quite remember Carl, but we became friends quickly. (CTA photograph, Carl Nelson Collection.)

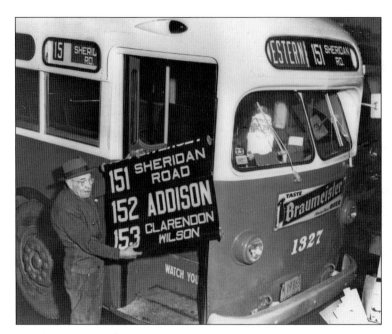

Painted in the new livery of light cream and forest green, CTA No. 1327 is getting new destination signs and a new fare register; an unwrapped one can be seen through the front window. The fare had been a dime for a long time. Then came a 3¢ increase followed shortly by a 5¢ increase, which made the dime register obsolete. The new register did the counting when the money is dropped in. (CTA photograph.)

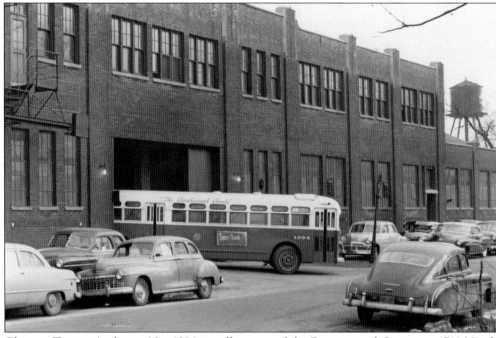

Chicago Transit Authority No. 1394 is pulling out of the Ravenswood Garage at 4711 North Ravenswood Avenue. (The Northwestern Railway runs in between the streets Ravenswood East and Ravenswood West.) No. 1394 will run east on Wilson Avenue, then on to the Outer Drive (Lake Shore Drive) exiting at Oak Street to State and Jackson. On his return trip during the evening rush hour, the driver's bus will be filled to capacity. Note: Lake Shore Drive was known as the Outer Drive. (CTA photograph.)

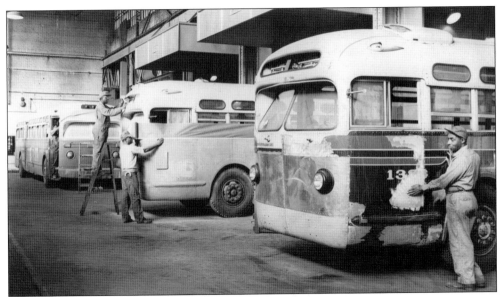

During the 1952 transition, the paint shop at the Keeler Garage on West Diversey Parkway was bustling. From left to right is Joe Tomkins standing on a ladder; Lawrence Brint taping; and Jack Jones preparing the surface for painting. Eventually, the interiors would also be painted in a two-tone aqua, which looked a bit gloomy compared to the CMC's interior light cream and forest green below the windows. (CTA *Transit News* photograph.)

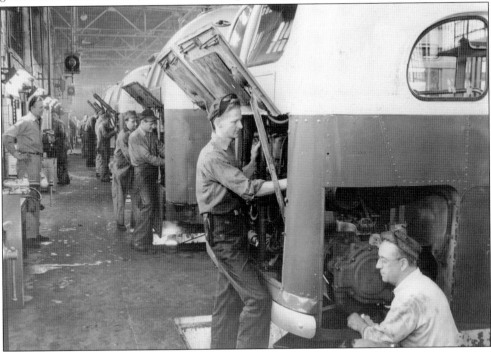

South and North Division buses would get their 4,000-mile checkup at the Keeler Garage, 4221 West Diversey Avenue, under the watchful eye of Henry C. Richter, inspector foreman. In the foreground, mechanic Bob Young (stooping) and Bob McCage (standing) are going about their skilled chores. The buses are all in the new CTA paint livery. (CTA *Transit News* photograph.)

In the background is a Route 49 Soldier Field shuttle bus weaving around a 4 Cottage Grove Pullman streetcar in 1950. Cottage Grove Avenue had a variety of streetcars and was converted to one-man PCC (President's Committee Car) streetcars in May 1952. In 1955, Cottage Grove Avenue became an all-bus operation. Ironically, the last time the author rode an ex-motor coach 500 Series bus was on Cottage Grove Avenue while in high school. (Robert W. Gibson photograph.)

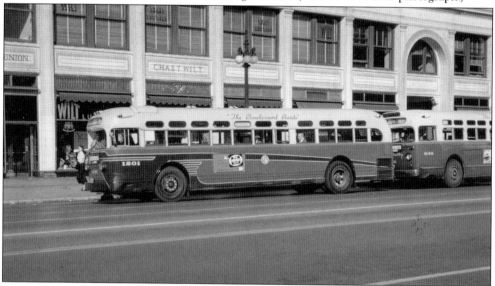

In this September 30, 1953, photograph, buses No. 1201 and No. 645 are still in their motor coach livery with the name painted over. Bus No. 645, an Outer Drive Limited, started its run at Ravenswood and Wilson Avenues. In the background at 224 South Michigan is the white-glazed terra cotta structure, the Railway Exchange Building, whose major tenant was the Santa Fe Railroad. It was built in 1904 by D.H. Burnham and Company and designed by Frederick P. Dinkelberg. (William Hoffman photograph.)

The front interior of bus No. 1330 after CTA takeover is still painted in the motor coach interior light-yellow cream and medium forest green. Later, the CTA would paint the interiors in two-tone aqua and replace the mohair seating with leatherette. No. 1330 is operating on 149 State-Wacker (former CMC Route 49) between the Merchandise Mart and Soldier Field parking lot. The bus driver is in the CTA navy-blue uniform. (CTA photograph.)

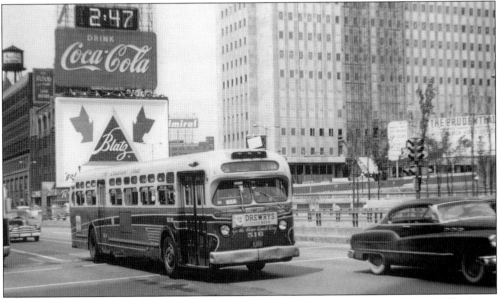

In 1954, CTA bus No. 516 is operating on its old motor coach route 51, now CTA 151. The driver already has his north destination sign set for Devon Avenue, although he is southbound to State and Adams Streets. No. 516, new in 1948, is starting to show wear but will be reconditioned into a like-new CTA bus, minus the mohair seating. In the background, the 41-story Prudential Building is under construction. (John F. Doyle Collection.)

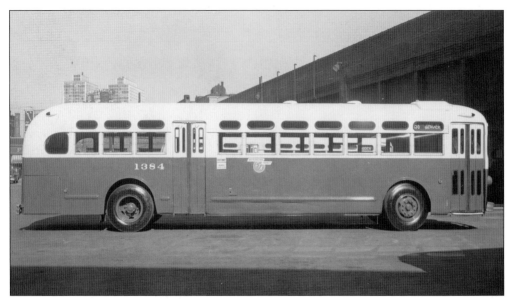

CTA bus No. 1384 is shown here in a company photograph around 1957 after being repainted and allocated new bumpers that took away that streamliner look. Shown here at Limits Car House at Clark Street and Shubert Avenue, No. 1384 will work its old motor coach routes, now CTA 153 and 156. The motor coach's GM buses turned over to the CTA proved their worth and lasted longer than their expected service lives. (CTA photograph.)

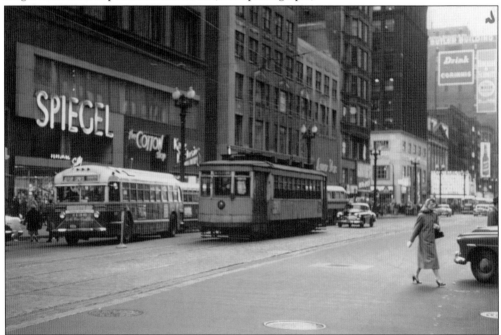

A 1939 Yellow Coach Jeffery Express, still in motor coach livery with the CMC name painted out, is operating southbound on State Street at Madison Street in 1954. The Pullman streetcar was 1 of 15 cars the CTA held back from the scrapper as extras in case they were needed to fill in for the PCC Green Hornet streetcars. It was rare to see them out on the street. The CTA discontinued the practice in October 1954. (Robert W. Gibson photograph.)

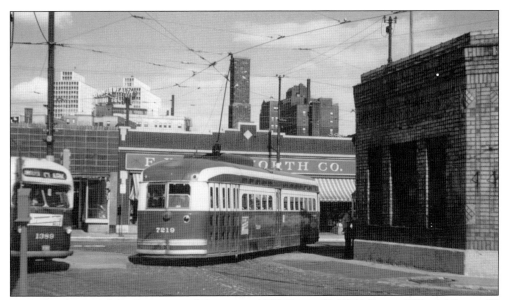

With the closing of the Ravenswood Garage in 1955, Route 53 (CTA Route 153) and Route 56 (CTA Route 156) would be moved to Limits streetcar barn at Schubert Avenue and Clark Street (2900 north). This barn was originally a cable car barn and was one block from city limits when built. A PCC Green Hornet streetcar is departing southbound while a former motor coach bus, No. 1389, is pulling in. (Robert W. Gibson photograph.)

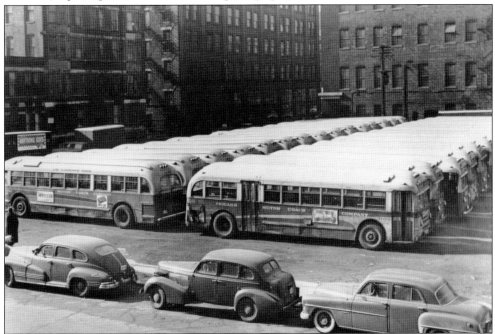

The motor coach also had three parking lots for storage after the morning rush hour. Pictured here is 18th Street and Indiana Avenue; that lot would be moved to 15th and State Streets after the CTA takeover. The Indiana lot would become a Yellow Cab lot. The other two lots were at Lexington Street and Des Plaines Avenue and Grand Avenue and Orleans Street. Fuel was saved, as the drivers would not have to deadhead back to their garages. (CTA photograph.)

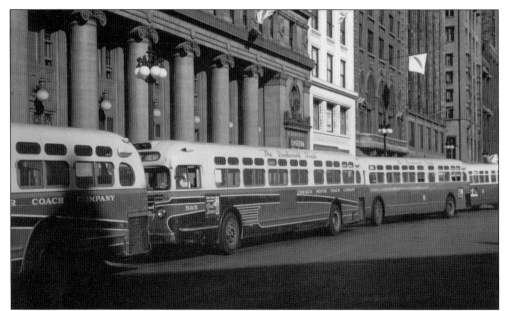

Pictured is a lineup of buses on September 30, 1953, in front of the Peoples Gas Company Building at 122 South Michigan Avenue. The first two 500 Series buses had no changes; the second 600 Series bus had the CMC letters painted over and replaced with a CTA roundel. The last bus is in the new CTA paint livery. The Peoples Gas Company Building was designed by the firm of D.H. Burnham & Company in 1910. (William Hoffman photograph.)

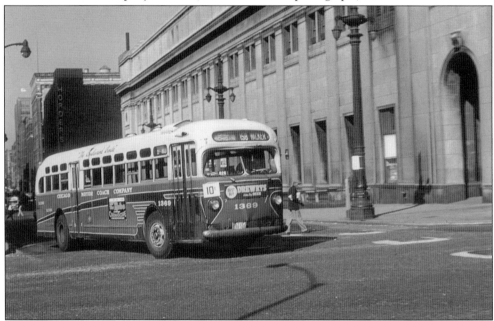

CTA bus No. 1396, run No. 826, is still painted in the livery of the motor coach, but with a new route number—158 instead of 58. Eastbound in 1952 on Jackson Boulevard, No. 1396 is about to turn north on Canal Street to its Union Station Terminal. The 10¢ fare is a reduced half-fare, since the two routes from Streeterville are considered short line shuttles, along with the parking lot routes. (William Hoffman photograph.)

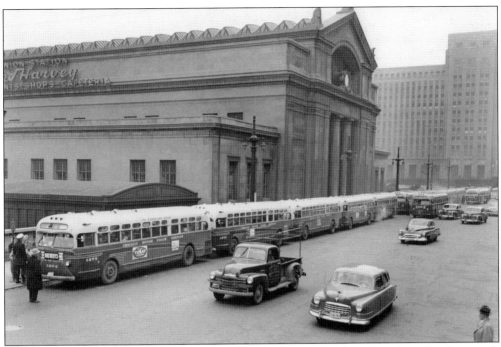

The motor coach was known to charter. As a choir boy, the author remembers that his parish would charter motor coach buses to bring them to singing events at churches throughout the city. He did not express his enthusiasm for the bus ride then, but would sing again, loudly, to ride those motor coach charters again. This view looks south on Canal Street to the post office in 1953. (CTA photograph.)

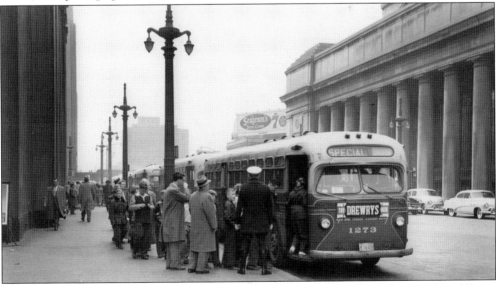

The lineup of chartered CTA buses still in their motor coach livery is shown here on Canal Street looking southwest to the magnificent colonnade fronting Union Station. Wearing a white cap is a Chicago city traffic policeman, outfitted in riding breeches and black leather puttees. Note the marker lights on the motor coach were green, not amber, which gave the buses a very distinct look at night. (CTA photograph.)

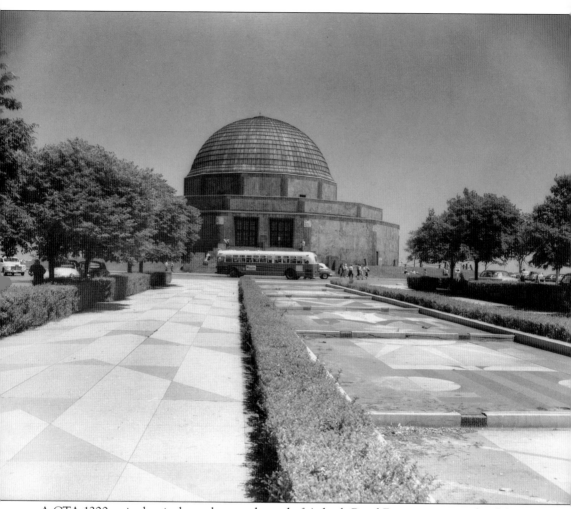

A CTA 1200 series bus is shown here at the end of Achsah Bond Drive, now named Solidarity Drive, still in motor coach livery in 1953. In the background is the Adler Planetarium, America's first planetarium, opened in 1930. The drive is named after the wife of the first governor of Illinois, Shadrach Bond. The bus is operating on Route 126 Jackson Boulevard, formerly CMC Route 26. The motor coach exclusively served Chicago's Museum Campus, which includes the Adler Planetarium, Shedd Aquarium, and the Field Museum. In 1923, Oskar von Miller of the Deutsches Museum delegated the Carl Zeiss Works to design a piece of machinery that would project a picture of outer space onto an interior dome. Designed by Walther Bauerfield, the invention was called the planetarium. Max Adler, retired vice president of Sears, Roebuck and Company, along with his architect cousin, Ernest Grunsfeld Jr., traveled to Germany to study the Munich Planetarium and purchase astronomical instruments in Amsterdam. Adler, in 1928, gave $500,000 to build a planetarium. Ernest Grunsfeld Jr. was the architect, styling the building in Art Deco. (CTA photograph.)

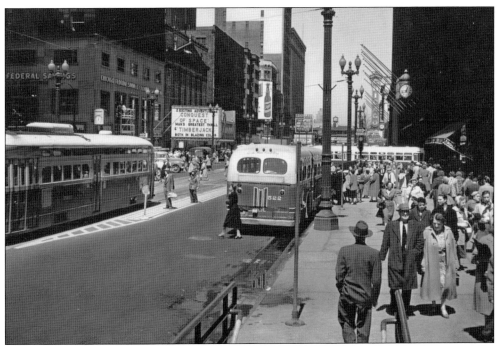

CTA bus No. 522 in need of paint is shown here in February 1955 in its original livery. The streetcar is operating on Route 36 Broadway-State. The Roosevelt Theater across the street has a special meaning for the author. Sworn into military service on March 8, 1958, with extra time before departure, he was given two tickets, for a meal and a movie at the Roosevelt Theater. (CTA photograph.)

In 1954, CTA bus-driver training is taking place in former Chicago Motor Coach No. 1423. The instructor is in his CTA summer uniform, and the trainees, other than their hats, await their uniforms. The interior of the bus is still in the motor coach livery of light-yellow cream and medium forest green. Also, the signage is still motor coach: "Please move to the rear of the coach." (CTA photograph.)

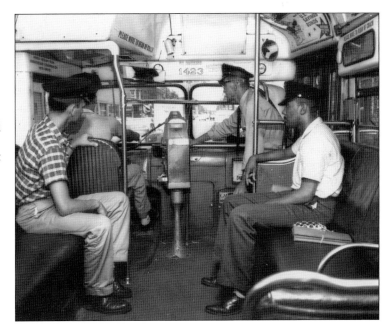

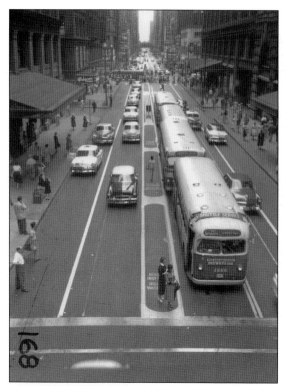

CTA No. 1368 is shown here from the "L" platform at Wabash Avenue, in this view looking west on Washington Boulevard in 1954. Painted in the livery of the CTA, No. 1368 is operating on Route 157 (former Motor Coach Route 57) and will connect the Northwestern Railway Station and Union Station to Streeterville between Ohio and Chestnut Streets. If the shuttle bonnet on the roof was up, then the bus was in parking lot service. (CTA photograph.)

The Chicago Rapid Transit Company, operator of Chicago's famous "L," was bankrupt when it was taken over by the CTA on September 30, 1947. Shown here in 1952, a Lake Street train is coming off the Loop and will continue west on Lake Street. The Ravenswood train is turning north. The photograph was taken from Tower 18. The trains are running in the same direction on the inner and outer Loop tracks. (William Jansson photograph.)

The CTA northbound 500 Series bus is still in its Motor Coach livery in 1955; the southbound bus is not. The remarkable structure in the background is Central Station, which opened in 1893 to meet the demands of the Columbian Exposition. At the time, it had the largest train shed in the world. Central Station was built by Bradford and Gilbert in Romanesque Revival style. Closed in 1972, the buildings were demolished in 1974. (CTA photograph.)

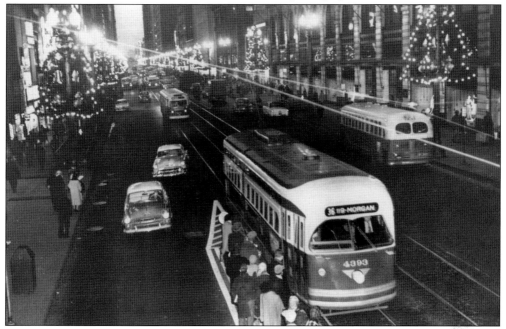

Looking north down State Street from Van Buren Street in 1954 are three buses still painted in the motor coach livery. Following the streetcar are two Jeffrey Express buses. This PCC streetcar, outbound to its South destination at 119th and Morgan Streets, is operating on the longest municipal streetcar line in the world. PCC 4393's return trip on this 24-mile one-way line will end on the far North Side at Devon-Clark Loop. (CTA photograph.)

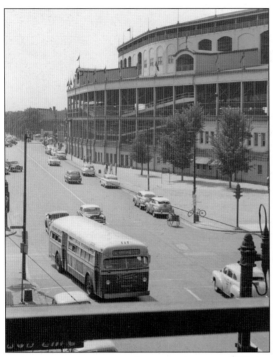

CTA No. 1005, one of eight Mack buses purchased by the Motor Coach, is going under the "L" on Addison Street at Sheffield Avenue in 1954. The ballpark was built by Charles Weeghman in 1914. The Cubs played their first game in 1916. In 1920, William Wrigley Jr. purchased the park. It is little known, but the Chicago Bears played football in the park for 50 years. The last Bears game there was on December 13, 1970. (CTA photograph.)

Chicago's famed Lake Shore Drive, also known as the Outer Drive, was Chicago's first express boulevard. This magnificent 16.4-mile Park District Highway ran along Lake Michigan from the North Side to the South Side. Lake Shore Drive began in 1933 for the Chicago's Century of Progress 1933–1934 World's Fair; it would be completed in 1944. In this photograph, taken from the North Avenue Bridge in 1957, is CTA No. 1384, a LaSalle-Wilson Outer Drive Limited. (CTA photograph.)

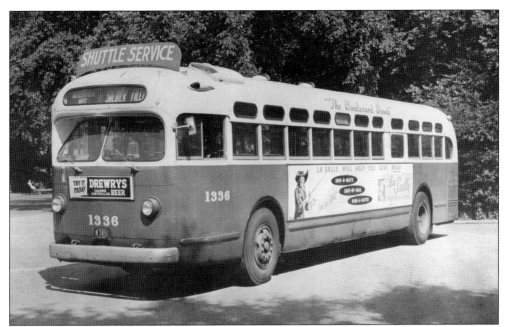

No. 1336, in CTA livery, sports the bonnet to inform riders that it is a parking lot shuttle bus. Advertising included the LaSalle Bank, chartered in 1927, which survived the Depression and had $100 million in deposits by the 1950s. Drewry's Beer, founded in 1877 in Manitoba, Canada, became a Chicago favorite and was brewed at the South Bend Brewery in South Bend, Indiana. On the label was a Royal Canadian Mounted Policeman. (CTA photograph.)

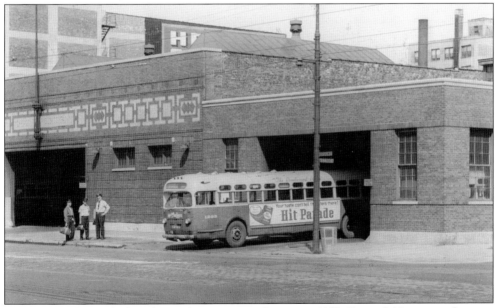

This picture shows the last day at the Rosemont Garage in 1957. Opened 40 years earlier as a Chicago Motor Bus garage and, in 1922, as a Chicago Motor Coach garage, it was now closed forever. The Ravenswood Garage closed in 1955, along with the Wilcox Garage at 4532 West Adams Street. The last two motor coach garages that closed were Keeler at 4221 Diversey Avenue that closed in 1973, and 52nd Street and Cottage that closed in 1983. (CTA photograph.)

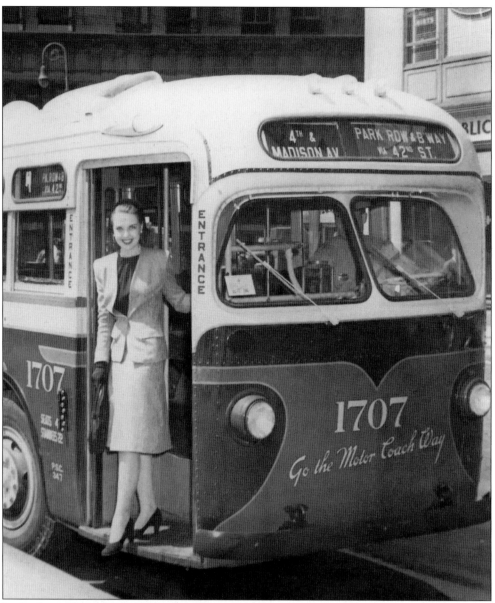

In Gotham, Chicago Motor Coach had cousins. Fifth Avenue Coach Company purchased New York Railways in the 1930s and replaced streetcars with buses. Shown here is a new 1946 GM Transit Diesel No. 1707 under the name Madison Avenue Coach Company serving on those former Manhattan streetcar lines. Posed for a publicity photograph, the young lady shows the fashions of the day. The city of New York wanted all streetcar lines replaced with a unified bus operation. One of America's best-run streetcar companies, the Third Avenue Railway System, was fully converted to buses in Manhattan and the Bronx by 1948, operating under the name Surface Transportation Corporation. On December 17, 1956, the New York City Omni Bus Corporation purchased Surface Transportation and operated the company as a subsidiary called Surface Transit Incorporated. The Omni Bus Corporation, the parent company of the Chicago Motor Coach Company, now with a new name, Fifth Avenue Coach Lines, had come full circle only to collapse by 1962. (*Motor Coach Age Magazine.*)

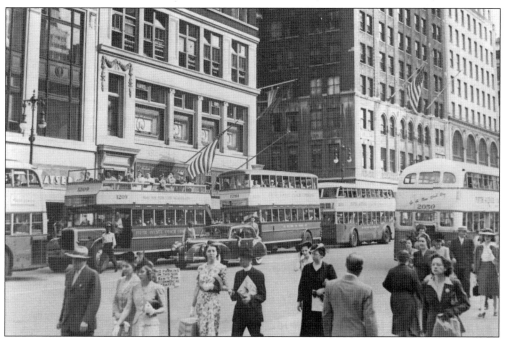

Fifth Avenue Coach Company has a variety of double-deckers working Fifth Avenue at 42nd Street in front of the public library in 1942. Chicago Motor Coach and Fifth Avenue Coach were the two most important companies that, in 1924, became part of the New York City Omni Bus Corporation. Note that Bus No. 2050 has a hump in the roof and would be used on routes that had higher viaducts. (*Motor Coach Age Magazine.*)

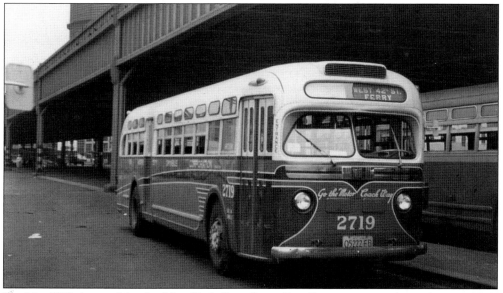

Bus No. 2719, lettered for the New York City Omni Bus Corporation, is shown here in 1949, assigned for West 42nd Street Ferry. By 1956, Fifth Avenue changed names to Fifth Avenue Coach Lines, and by 1962, they were bankrupt. All operations were taken over by Manhattan and Bronx Surface Transit Operating Authority, a public agency. In retrospect, 10 years earlier (1952), the Chicago Motor Coach sold at the right time. (John F. Doyle Collection.)

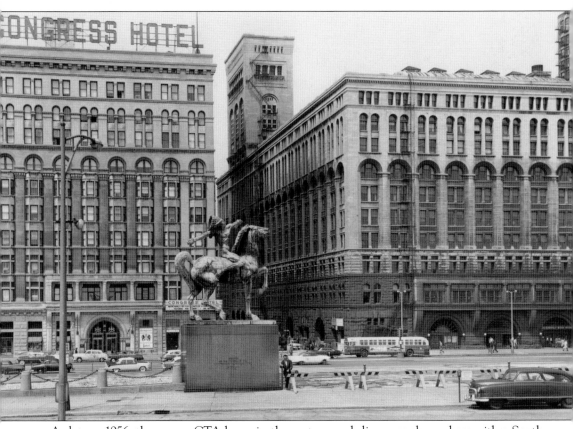

As late as 1956, there were CTA buses in the motor coach livery, as shown here with a South Side bus crossing Congress Street. This magnificent photograph shows the Congress Hotel and the Auditorium, to the right. The Congress Hotel, originally known as the Auditorium Annex, opened in 1893 for the Columbian Exposition. The Auditorium Theatre and office complex opened in 1889. In 1908, the hotel was renamed the Congress Hotel. *The Spearman* and *The Bowman* (not shown) are 17-foot-high statutes defending a giant stairway entrance into Grant Park. The stairway was removed in the 1940s when Congress Parkway was extended. Missing their weapons, the artist preferred that it be left to the viewer's imagination with attention focused on the man and the horse. The American Indian sculptures were made in Zagreb, Croatia, by Ivan Mestrovic and were installed in 1928. Statues were a large part of Daniel Burnham's 1909 *Plan of Chicago*. Mestrovic later came to the United States and retired as a celebrated professor at Notre Dame University. In 1945, Roosevelt College (now University) moved into the Auditorium; the college purchased it for $1 in 1947. Today, the building is fully restored after going into decline. (CTA photograph.)

"The Boulevard Route"

This chapter ends the Chicago Transit Authority's operation of the Boulevard Route Division. The last buses would be painted in the livery of the CTA, and the Chicago Motor Coach Company would soon be forgotten. At least with this book, we got to ride the Boulevard Route one more time. (Drawing by John F. Doyle.)

Twenty years after the CTA purchased the CMC, the author returned to this location in 1972 to take another look. The building to the left is where the author lived. The sidewalk all the way down to Broadway was where he and his Radio Flyer wagon became Chicago Motor Coach bus and driver. CTA No. 9277 is signed for the former CMC destination a few blocks west, now 153 Wilson-Ravenswood. (John F. Doyle photograph.)

From the author's earliest memories, the Monitor Cleaners was on the corner. In sixth grade, the author was a patrol boy on this corner. Clark Street was a heavy streetcar line, Route 22 Clark-Wentworth. As evidenced in the 1972 photograph, the driver is still making a "far side of the intersection" service stop. This motor coach practice still is used by the CTA today on most former motor coach bus stops. (John F. Doyle photograph.)

CTA No. 9307 is at the bus stop for the Lincoln Park Conservatory on Stockton Drive and Fullerton Drive in 1972. The impressive statue of Carl Von Linne, a famous Swedish botanist and naturalist, appropriately faces the conservatory. It was placed in the park with the help of Chicago's Swedish community on May 23, 1891. With the widening of Fullerton Parkway, the statue would be removed in 1976 to the Midway Plaisance. (John F. Doyle photograph.)

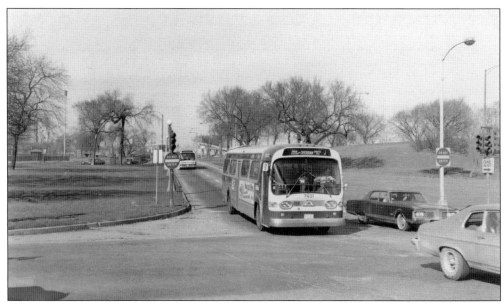

Two CTA buses operating on Chicago's first bus route Sheridan Road, now CTA 151, are coming off the drive at LaSalle Drive East and going on to the inner Lake Shore Drive. By this time, the CTA was being supplied with all GMC buses, but for GM, their bus-building business was in decline, and eventually, they would cease the manufacturing of buses altogether. Nova Bus was the successor company to General Motors' truck and coach division. (John F. Doyle photograph.)

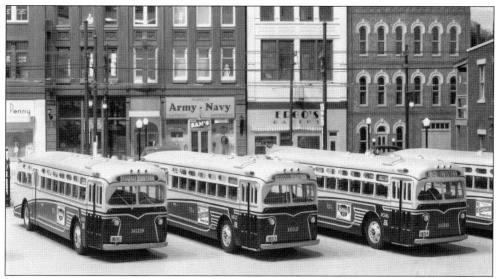

Shown here on the imaginary date in May 1946 is a lineup of new GMC 41-passenger transit diesel buses. The scene is on the John F. Doyle O-gauge transit layout, consisting of 27 buses, 24 streetcars, and 8 trolley buses. The streetcars are city, suburban, interurban, and work equipment. The buses were scratch built by Dave Haire of Toronto, Canada. The background buildings were built by Dave Lull. (Lawrence Godson photograph.)

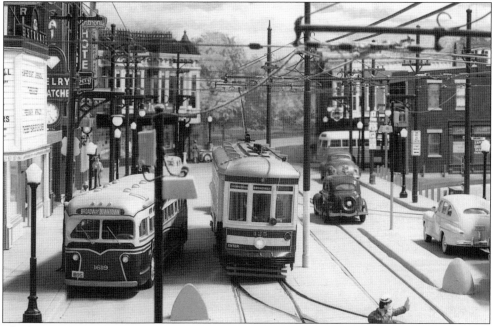

The last "owl service" bus has just finished its run. United Traction streetcar No. 425 is about to make a service stop on Broadway at Sunnyside Avenue in Upper St. Claire. Daniel Pantara completed eight brass streetcars with added details by Larry Konsbruck. The layout was built by Larry Konsbruck with assistance from the author. Wooden layout structures were built by Phil Dutch and Paul Cilwa. (Lawrence Godson photograph.)

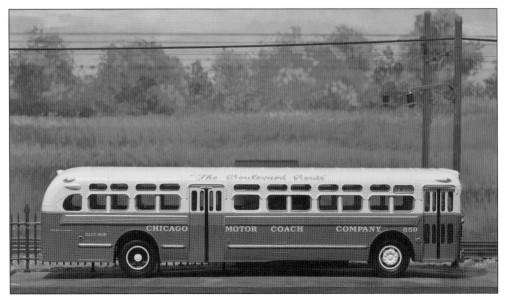

Chicago Motor Coach bus No. 659 is signed for Route 53 Clarendon and Wilson, the route the author lived on until eighth grade. This stunning O-gauge model was built by St. Petersburg Tramways, in St. Petersburg, Russia. The scene is on the John F. Doyle O-gauge transit layout. Dinky Toys made a very small toy bus; as a child, the author had a fleet of them. He wore a hole in the rug pushing them around the dining room table. (John F. Doyle photograph.)

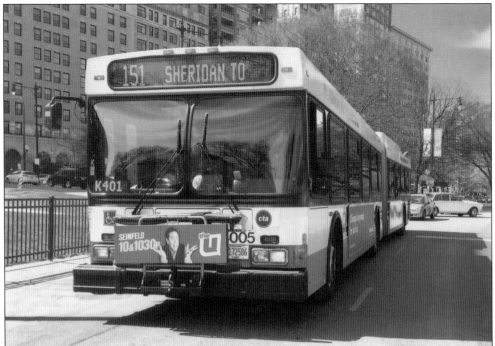

On Stockton Drive, April 22, 2018, a total of 101 years after the first bus ran on Sheridan Road, is a 151 Sheridan Road local across from the Lincoln Park Zoo. The old Chicago Motor Coach route number would have been 51 Sheridan Road. This modern bus is like a spaceship when compared to this book's cover photograph, taken nearby on July 18, 1923. (John F. Doyle photograph.)

ABOUT THE AUTHOR

John F. Doyle is pictured here in 1982 driving a charter for Commuter Bus Systems, owned by Robert McCreary, who operated buses for the Regional Transit Authority (RTA). Bus No. 401 is a 36-passenger GMC transit diesel originally owned by Cincinnati & Covington Street Railway. The charter was a special event for the company. Doyle was raised near Clark Street and Wilson Avenue, within walking distance to several streetcar lines, "L" lines, and trolley bus lines. He lived on a Chicago Motor Coach bus route. Moving to the South Side of Chicago in eighth grade, he graduated from Mendel Catholic High School. Doyle spent three years active duty in the US Marine Corps. Doyle worked for Butternut Bread in Chicago for 40 years, which included 32 years as an account representative of Jewel Food Stores, the largest grocery chain in Chicago at the time. Always interested in transportation, he worked briefly as a locomotive fireman and, for several years, drove RTA diesel buses part-time. Doyle also served on the Chicago Transit Authority Citizens' Advisory Board for three years. He and his wife, Diane, reside in Western Springs, Illinois, a suburb of Chicago. (Diane J. Doyle photograph.)

DISCOVER THOUSANDS OF LOCAL HISTORY BOOKS FEATURING MILLIONS OF VINTAGE IMAGES

Arcadia Publishing, the leading local history publisher in the United States, is committed to making history accessible and meaningful through publishing books that celebrate and preserve the heritage of America's people and places.

Find more books like this at
www.arcadiapublishing.com

Search for your hometown history, your old stomping grounds, and even your favorite sports team.